THE LONG RUN

Also by Stacey D'Erasmo

Tea
A Seahorse Year
The Sky Below
The Art of Intimacy: The Space Between
Wonderland
The Complicities

THE LONG RUN

A CREATIVE INQUIRY

STACEY D'ERASMO

Graywolf Press

Portions of this book previously appeared in slightly different form in the *Georgia Review*, Spring 2023.

This publication is made possible, in part, by the voters of Minnesota through a Minnesota State Arts Board Operating Support grant, thanks to a legislative appropriation from the arts and cultural heritage fund. Significant support has also been provided by other generous contributions from foundations, corporations, and individuals. To these organizations and individuals we offer our heartfelt thanks.

Published by Graywolf Press
212 Third Avenue North, Suite 485
Minneapolis, Minnesota 55401

www.graywolfpress.org

Published in the United States of America

ISBN 978-1-64445-292-9 (paperback)
ISBN 978-1-64445-293-6 (ebook)

2 4 6 8 9 7 5 3 1
First Graywolf Printing, 2024

Library of Congress Control Number: 2023951384

Cover design: Kyle G. Hunter

Cover art: Adolph von Menzel, *Altar in a Baroque Church* (unfinished). Ca. 1880–1890. Oil over blue pencil underdrawing on wood. Photo credit: bpk Bildagentur / Nationalgalerie/Staatliche Museen, Berlin, Germany / Klaus Goeken / Art Resource, NY

Dear Friend,

The essence of all beautiful art, all great art, is gratitude.

—Friedrich Nietzsche

Contents

THE LONG RUN

Prologue: The Question

How do we keep doing this—making art? My question can be read in two ways: What keeps us alive in our art? On what do we draw, year after year and project after project, to keep doing this? And, what happens to us as we keep doing this? In what manner do we keep doing this?

When I began asking this question in an essay I published in the *Rumpus* in 2010, I had never felt more alive in my own vocation. I was working on two projects that were dear to my heart, and all I wanted was more time and space to finish them. I had an official community in my teaching life, and a thick community in my personal life that was fundamental to my work. So when I asked back then, *How do we keep doing this?*, my interest was keen, but a little academic. I wanted, more or less, a map of the road ahead that would show me what to expect and what to do. My friend the writer Andrew Altschul and I thought a good book could be made from my essay by soliciting essays on the long run from various writers and artists who were older than we were. We lined up some great folks and started shopping the anthology around.

Then things changed. For different reasons, first my personal community and then my official community fell apart. I did finish the two projects and launched them into the world, but while they

were well received, they didn't live up to the expectations with which they were published. For about five years—beginning in 2010, funnily enough—things kept breaking. Relationships broke, friendships broke, promises broke. Where I lived, who I lived with, who I counted on, who counted on me, and where I worked all changed, sometimes quickly and vertiginously. Many facets of my identity shattered. No one wanted the anthology, although Graywolf did want a nonfiction book by me extending my essay. About four years after I published that essay, though, I found that, while words might flow initially, I couldn't sustain a project. After twenty pages or so, I would lose interest and momentum. The words seemed weightless, rootless, tinny. I kept trying and I kept failing. I couldn't write this book, or any book.

It was extraordinarily painful and bewildering. For as long as I had been writing seriously, more than twenty years by then, I could always find the well no matter what else was happening in my life or in the world. I wrote with and without money, during times of family upheaval, throughout breakups, on the road, in dilapidated barns, in splendid rooms of my own, and on sticky notes while riding the subway. When my therapist of many years died unexpectedly, I wrote. When a close family member went missing, I wrote. When I left a lover, I wrote. When a lover left me, I wrote. When I had a deadline for a book, I wrote, and when I had no book contract and no idea if I could get one, I wrote. When my publisher seemed to be going out of business and editor after editor left, I wrote. There might be obstacles to the well, minefields and bears, but those obstacles weren't generated by me. Now, however, I was lost. I still don't know how articulate I can be about why this particular confluence of events was my kryptonite. Call it a loss of faith. Perhaps I was simply overdue. Eventually, the pall lifted, but by degrees, not in a single revelation.

Meanwhile, I kept trying to extend that essay into a book, and compiled long lists of writers and artists to interview. I knew that

my question—what has sustained you over the long run?—was un-answerable, but I figured that the consideration of that unanswer-able question would yield complexity and nuance and the visceral texture of life: the aged dancer's foot, marked and deformed and sculpted by decades of chosen use. But as I was interviewing the artists whose long runs I admired, I found that I didn't want to write straightforward profiles of them. In one way, it all felt a bit in-vasive, and also frustrating: the profound connections between the life and the work often can't be articulated, and/or, people aren't going to tell you what they are, no matter how clever you are at try-ing to get it out of them. One woman, who took breathtaking risks to make breathtaking art, dismissed my interview request alto-gether, saying, "I don't give out details of my personal life, as it has little do with my work." To which I thought, *Oh, come on.*

How was it my business anyway? Why should these amazing older artists, or anyone, bare their souls to me? At the same time, I found that I was becoming drawn by an equally quasi-impossible desire to articulate how my own sensibility has developed over time—my own long run. I discovered that I had grown older not being able to write the book I had first intended to write. I wasn't as old as the amazing older artists, but I was old enough. I wanted to say how it was for the queer writer and woman I was becoming when I was young, and how that has changed over time. I wanted to get at something, a sort of personal zeitgeist, that will go away when my generation goes away.

I began again, with a deeper sense of urgency and consequence. Now I knew what it was like to sustain a vocation over decades. Now I knew, viscerally, that losing one's sense of vocation is like being in hell. My curiosity had become bloodier and more insistent: How *do* we keep doing this? What happens over a lifetime of doing this? In urban planning, the habitual paths taken by people on foot or on bicycle rather than the paved roads, which either don't exist or are too linear and awkward, are called "desire paths." What do the

desire paths of writers and artists who have done this over a lifetime look like?

In my own long run, one of the main things I have always reached for to sustain me is company. The company of lovers. The company of friends. The company of other writers and artists, living and dead. With this book, I created a circle of elders, my own chosen ancestors in this vocation. They did not, of course, ask to be this for me, or for anyone. They simply lived their lives. This book is a love letter, but it is also a demand. Maybe all love letters are demands. In any case, what seems clear to me is that I have always found it sustaining to turn to someone else and say, "This is how it is for me. How is it for you?"

I felt that I would have better conversations with people I didn't know too well, or at all, that my approach to them would be more open that way. Often the people I found who were willing to talk to me at length about such a personal and impossible question were friends of friends, people who had been neighbors, people who had worked with people I knew. Via this informal network of a few or more degrees of separation, I found the visual artist Cecilia Vicuña, the dancer Valda Setterfield, the landscape designer Darrel Morrison, the writer Samuel R. Delany, the actress Blair Brown, the painter Amy Sillman, and the musician Steve Earle. Feeling certain that no one would write me back, I cold contacted the Pulitzer Prize–winning composer Tania León through her website, and, amazingly, she agreed to be interviewed several times. I've included scenes from my own life where and when they seemed relevant; this book is a fugitive, occasional memoir.

This book itself, of course, is a desire path. It is subjective, partial, incomplete. It is not definitive. It is not an instruction manual. It is not canonical. It is a collection of glimpses, of questions, of conversations in reality and in the imagination. It's how far I've gotten.

Freedom

We believed in it. I believed in it. I was born in 1961, so this is the sixties I'm talking about. By the time I was in elementary school, my family had moved from New York City, where I and my younger sister were born, to the suburbs of Washington, DC. My mother was a nurse who worked at a local hospital. My father was a lawyer, the first person in his extended Italian immigrant family to get past the eighth grade. Sometimes, my father would take his Super 8 camera to the marches happening in DC and film the young people streaming down the avenues with their signs and banners, particularly the young women, particularly if they were dancing. We were Democrats, so I was anti-war, of course, in a perfunctory eight-year-old's way, but my gut idea about freedom was that image I saw in the home movies on the little screen my father would set up in our living room: young people with long hair walking somewhere fervently. I imagine now that they were going toward the White House, but back then I didn't know, or care, what their destination was.

Years later, when I read the Ursula Le Guin fable "The Ones Who Walk Away from Omelas," with its resounding image of a few principled people leaving a place of great delight founded on brutal exploitation, walking away from their home of Omelas toward an unknown horizon, it tapped that earlier image in my private archive of those marches. My image of freedom was, and is, that

earnest walk toward an unknown destination. Freedom meant leaving: leaving the Old Country; leaving Newark, then New York; leaving narrow-minded families and small towns; "She's Leaving Home," by the Beatles. In the second half of the Western twentieth century, where I grew up, freedom was airplanes, fast cars on highways, perpetual motion, hitchhiking, astronauts, bare skin to air and light, no speed limit.

=====

The 1960s were also a time when many forms of art walked away from conventions. The dancer and performer Valda Setterfield came from England to New York in 1958. She was twenty-four. I interview her, at eighty-seven, on Zoom, because it's the time of the Covid-19 pandemic, even though she lives fewer than five miles away from me in New York City. She was born in 1934 and grew up in Westgate-on-Sea, in southeast England, near Dover. She had had a haphazard dance education, mostly focused on ballet, when she arrived in New York to study with modern dance innovator José Limón. She danced with the James Waring Company from 1958 to 1962. She married fellow dancer and choreographer David Gordon in 1961; they had a son, Ain, in 1962. Around this time, she began taking classes with Merce Cunningham, who said to her one day, "Don't make everything so pretty." She had been told the opposite for years, and the relief was "indescribable." She says, "I stopped every single bit of it." She realized, "I don't need to smile. I don't need to charm anybody."

She uses the word *honest* many times when recounting how she felt about this new way of dancing. "Nothing was forbidden," she says. She danced with the Merce Cunningham Company from 1964 to 1975, but there is a sense in which she is still dancing with Merce, still in conversation with his iconoclastic spirit. She quotes him with love, often. As her career progressed, she worked

with Yvonne Rainer, Robert Wilson, Mikhail Baryshnikov, and JoAnne Akalaitis, among many other major artists. Her husband established the Pick Up Performance Company in 1971, and he and Setterfield became an epicenter of dance, theater, and performance. They were part of the generation that created postmodern dance, which often saw no difference between dance movement and everyday movement like walking and talking and leaned heavily on improvisation. In fact, Gordon called himself a "performance artist," not a choreographer. One might say that if modern dance leaders like Cunningham opened a door, artists like Gordon and Setterfield not only took the door down, they also removed the entire wall around it, as well as the building.

Gordon and Setterfield, who were once referred to as "the Barrymores of postmodern dance," lived in a five-story loft building in SoHo where their neighbors were other dance innovators such as Trisha Brown, Lucinda Childs, and Douglas Dunn. In a novella-sized *New Yorker* profile of Gordon and Setterfield written in 1982, Arlene Croce relates that their loft included an ample rehearsal studio, a hot tub, and, for Ain, "a two-story cubicle with a window cut in one side." Setterfield's life and her art seem to have been a seamless whole. She performed well into her eighties; one of her last major roles was as King Lear in a piece by John Scott, an Irish choreographer, in 2016.

Setterfield is like an arrow. In addition to the word *honest*, she likes the word *useful*, taking pains to tell me that she is not a maker, not a choreographer either: "I like to feel useful." In videos of her in performance, she is fascinating in her trueness, in the sense that a wheel is true. She is tall—too tall for ballet at five feet eight—most frequently blond to platinum-haired, with a mobile face and large eyes that gaze very straight. In images from the sixties and early seventies, she has a mod look: very short hair, very long eyelashes, all face and legs. Onstage throughout her life, she seems to embody the real, which is revelatory and slightly frightening. When she

walks, she *walks*, with utter presence. Her arms and legs seem to extend even past their lengths, leaving trails in space. Every movement seems not so much choreographed as the result of a very specific decision she has made just at that moment. Often, the work she made with Gordon includes dialogue, and though sometimes this was meant to be improvised during the performance, every syllable in her alto voice lands squarely. She may say she just wants to be useful, but in performance her vibe is more like a goddess who could smite you. In person, she's gracious, engaged, and without vanity. Before one of our conversations, she had had dental work done, so she was temporarily missing some of her front teeth. She laughed about it.

She tells me several times that she "wants to be part of now, part of *this* time." It is a practice she seems to have followed all her life. After the attacks of 9/11, she looked around that storied loft in SoHo and decided to get rid of decades of papers and other artifacts from her career. Her husband was horrified, as am I, a little. But, she says, "What I have are the memories, and they're as clear as anything—the feelings, the smells, the tastes, the sounds. I don't need paper souvenirs." When she says this, it is as if a dust storm of sentimental clutter blows away. All at once, I understand that iteration of modernism that drives toward the core, the skull beneath the skin: the direct lines of the architecture of Le Corbusier and the unembellished designs of the Bauhaus. Things don't need to be "pretty," as in prettied up; they are complete and meaningful just as they are.

Here is a story she tells me. When she was about four or five, her dance teacher asked if she would do a solo at a garden party. About the day of the party, she says, "Immediately it was amazing. The smell, the air, the blossoms, the people. They were watching, and I felt a connection there. So I began to do my dance, which began with me running around in a circle, and then there was a change in the music and then I had to go to the center and do what I thought

was a very hard little step. But as I got closer to the time, I thought, I don't remember what that little step is. Well, I think I'll just keep running and when we get nearish in the music, maybe I'll remember. But I didn't remember, so I kept running. In the audience was a little patter of laughter, but nobody was mean or cross and they kept watching, and I thought, *This is wonderful. I feel their friendship. I feel their support.* So I ran all the way through the music to the end and ran off to huge applause."

Oddly, or perhaps not, this dance of simply running in a circle that was danced by a little girl in the 1930s in a garden in a seaside town in England seems like a modern dance, a Cunningham piece scored by John Cage. Who needs the fancy step in the middle?

It's a way of moving. It's motion freed from narrative, just the thing itself. From the rubble of wartime England, an arrow to New York City in the early sixties, where Setterfield and Cunningham and Cage and Robert Rauschenberg all went out to the Automat together to eat and talk. Where Gordon, two days after Ain's birth, went to dance to Erik Satie at Judson Church. Where, as Yvonne Rainer has described the modern dance zeitgeist, "You just 'do it,' with the coordination of a pro and the innocence of an amateur." For Rainer, as it was for Setterfield, that zeitgeist was a "beautiful alternative to the heroic posturing that I felt continued to dominate my dance training." Talking to Setterfield, I feel that rush of freedom from ossified posture, restriction, and convention.

===

At Dia: Beacon, a 1969 sculpture by minimalist artist Fred Sandback is simply four pieces of yarn forming a square that runs from floor to ceiling in the vast gallery. If you look at this outline of a square, you will suddenly be able to see planes in space—the invisible made visible. You might, then, become aware of infinite planes in space, all co-inhabiting the space you're in. Sandback made many of these

outlines in which strands of yarn drop straight and true, like plumb lines, from high to low, as if actually following tracks in the air. These ultralight sculptures are revelatory, and also strangely claustrophobic. They mime walls. It isn't surprising that Sandback suffered from depression (he died by suicide in 2003, at fifty-nine). He sees walls where others don't, and his work makes them visible, over and over, trying to show us. I never fail to be shocked and moved by these pieces, astonished by the economy of means that accomplishes such a weighty metaphysical task. With a few pieces of yarn, Sandback transforms our very way of seeing. You don't need all that construction and artifice. The world is already full. All you have to do is recognize it. Open your other eyes.

===

In my young lesbian adulthood, this was how I understood desire—as a verb, a motion, a continual orienting and reorienting toward a trueness with oneself, a plumb line. I came out as a lesbian around 1980. I say *around*, because it isn't really a discrete date; it's more wave than particle. But let's say the wave was high then—I had an actual girlfriend (with whom I was mostly miserable); I told my parents (who were mostly miserable about it). I began going to meetings of Lesbians at Barnard (LAB), which happened after hours at the Barnard Women's Center and were tolerated, at best, by the university.

In our classes at school, we read *Pamela* and Pope and Milton. The books we passed from hand to hand, though, were by Adrienne Rich, Mary Daly, Jill Johnston, Audre Lorde, Shulamith Firestone, Judy Grahn, Monique Wittig, and Maxine Hong Kingston. I had spent every afternoon of my senior year in high school reading Simone de Beauvoir's *The Second Sex* while listening to Keith Jarrett records, often wearing a gold polyester robe that I had cleverly sewn down the middle to make a dress, so I felt I was primed for radical

new ways of being. In college, I also found Edmund White, Andrew Holleran, André Gide's *The Immoralist*, Michel Foucault's *The History of Sexuality*, James Baldwin's *Giovanni's Room*. I was riveted by the density and strangeness of writers like Virginia Woolf, Jane Bowles, and Violette Leduc. I began to understand that there was a place called culture, and that everything could happen there.

At LAB meetings and everywhere else, we talked about the leftist Sandinista revolution in Nicaragua and the right-wing junta in El Salvador; about the pros and cons of lesbian separatism; about monogamy; about rape and other forms of violence against women. We had lots of identity words, but the ethic was radical honesty about what you wanted, which was understood to be subject to change. Like the concept of freedom, this was an ideal, with the usual unsteady relationship to life. Also, I say "we," although I can't speak for an entire moment in time, obviously. My experience is as singular as anyone else's, as everyone else's.

Our tribe was ready to remake the world and rewrite history. One of us, who went downtown at night to mysterious places called CBGB's and the World and listened to the Slits and the Bush-Tetras, made a video in which we all played different goddesses. (I was Athena.) Another of us, a grad student, was researching the possibilities of parthenogenesis, which we totally believed could happen very soon. We were both ridiculous and brave. Not one of us then, that I can remember, had anything close to a good coming-out story. We had been disowned, pulled out of school, shamed, variously punished or pathologized, or just didn't dare come out to our families or communities at all. And overall, if this queer education seems pretty white and Western—well, yes, it was.

We weren't all white, though, we young women of LAB; we weren't even all Barnard students. Sometimes women with names like Artemis drifted into our parties, looking dusty and serious and revolutionary, bringing news from the gender frontier. (Also, I think she seduced my girlfriend, but that's another story.) Others

showed up there from Columbia grad programs or from elsewhere in the city. A woman with a weathered face came to warn us about COINTELPRO. I didn't know whether to believe her. Did the FBI really care that I had stopped shaving? Often, a bunch of us piled into Checker cabs and went down to the West Village to the Duchess, a lesbian bar with a jukebox and a small dance floor that had been there since 1972. Barely ten years after Stonewall, which was across the street, the dyke style at the Duchess leaned toward popped collars, chinos, and mullets. One night, I was there with the misery-inducing girlfriend, who favored multiple earrings, punky hair, and several colorful layers of skirts and tops, and who hand-rolled her own cigarettes out of a little pouch of Drum tobacco. I had long, straight hair parted in the middle and still wore the jeans and sweaters of my high school days; in the winter, I topped this with an enormous man's thrift store wool coat. As we were dancing together, a woman sketched us and showed us the picture: hippie-ish girls, we looked like. I think we must have looked peculiar to her, this raggedy new generation, slow-dancing to Rose Royce's "Wishing on a Star."

Forty years later, it's difficult to convey the continual feeling of risk, of being in unknown and possibly dangerous territory, and of defiance with which we lived. Barnard girls taking a cab to a West Village bar? Not exactly resisting the junta in El Salvador, as the highly anxious me of 1981 would have been the first to point out. But those of us in the cab—middle class and working class and from Hollywood money, from cities and suburbs and small towns, holding tight to our new haircuts and piercings—were only there together because we were on the same latitude of desire. Under other circumstances, we might not have known one another, or even liked one another, at all. The bar we were going to was one of a handful of lesbian bars in the city then, and it had been raided as recently as 1980. None of our professors were out, not even the one who was rumored to be lovers with Kate Millett and brought

her dog, wonderfully, to class. (For years, I associated queerness with transgressive pet practices.) In the broader cultural world— books, music, art, film, government, the sciences, anywhere—very few people were out. Reagan was in office. The religious right was on the rise. AIDS was about to happen, though we didn't know that yet. But in that cab, we felt free. In the cab, in the bar, it was bright and funny and sexy and we had our own words for things. We had left where we had come from. Some of us couldn't go back home at all; when some of us went home we had to pretend; when some of us went home it was to a firestorm of anger and fear and hatred.

It was as if that cab was driving through a desert. Deserts have much life in them, and so did America in terms of queerness, particularly lesbianism, in the early eighties. But, like a desert, much of it was underground, nocturnal, camouflaged. You had to know where to look, and to watch. You had to know the plumb lines of your own desire and be strong enough to follow them wherever they led out into the world. It could be that they led you to a married woman, a nun, a woman who looked like a man, someone older, or from another country or class or race, someone who swore they weren't a lesbian and yet kept showing up in your bed, someone who seemed a little crazy (so what, weren't women often called crazy?), someone who didn't dress or walk or talk like anyone you had ever known. "I am living a sexuality I don't understand," said Amber Hollibaugh at the 1982 Barnard Conference on Sexuality, which became notorious as a battleground between what came to be called "pro-sex" feminists and anti-porn activists. Our earnest tribe, sitting on the gym floor listening to Hollibaugh, all knew exactly what she meant. Our desire, which might look to outsiders like something not much more valuable or interesting than a bit of yarn, was the meridian of our very lives. Something powerful existed where most other people saw nothing at all. In a world where so much remained covert, coded, forbidden, endangered, and closeted, we had to trust our own instincts to get what we wanted. The

stories and the sentiments that the rest of the world found important: they weren't maps we could use. You knew where you were by the look in her eyes, the way she moved, the current between you. You went toward that. Our other eyes were open.

The feminist critic Ellen Willis, whose writing I very much admire, wrote in the *New Yorker* in 1974 that, while she appreciated the aims of women's music—a folk-inflected genre in which the leading lights were out lesbian musicians like Holly Near and Meg Christian—it didn't turn her on the way listening to the Rolling Stones did. Point taken, in regards to the strumming on acoustic guitars. It seems to me, however, that Willis was looking in the wrong direction. What was turning us on—me, anyway—was the audience. In those years, if you were at one of those concerts, you knew what everyone else was there for.

The texture of that time among new lesbians was rough: the buzz cut, the unshaven legs and armpits, the leather jackets, the overalls, best worn with nothing underneath. In the generation before us, the mode was butch/femme, with its glamour and sexual theater. Those women looked like people dressed for nightclubs. We looked like people ready, willing, and able to build new worlds out on some frontier. In the new world, we would also have entirely new modes of life, sex, and beauty. My roommate one summer chopped off all my high school girl hair with the kitchen scissors and then handed them to me. "Just cut off any parts you don't like," she advised me on styling maintenance, before we slept together. The sound was disco, the folk ambience of women's music, and punk. That same roommate who chopped off my hair had a Lou Reed record with a song that went, over and over, "I am just a gift to the women of this world." I liked to drop the needle on that song and on the Pointer Sisters' "Here Is Where Your Love Belongs." The drugs were cocaine (lots), dope, and alcohol. The taste was Café Bustelo made in those little angular stovetop espresso makers. The smell was cigarette smoke, permeating your clothes and your hair after a night out; and the faintly

alcoholish scent of Kiehl's Creme with Silk Groom, to make your hair spiky. The feeling was unbridled desire in an antagonistic world, like roses constantly blooming against barbed wire. The reason we were all in the cab together was to share the fare, and because it was hotter to have to be pressed up against one another.

Along with everyone else in that cab, I mobilized against lesbian invisibility and made sure to be visible in as many contexts as possible—class, Christmas, the deli, waiting for the WALK sign. But that phrase—"lesbian invisibility"—covers over the highly relevant fact that we were never invisible to one another. Learning to see what others couldn't was a vital part of my queer generation's coming of age. The summer before I went to college, in 1979, I had spent a lot of intense time with a bisexual Black theater director twice my age. (It was complicated.) (Which you can't say anymore.) (But it was.) One night, in my platform shoes, tan stockings, and tight polyester dress with all the stripes, which was my favorite outfit, I went with him to see a local theater group's production of Stephen Sondheim's *Company*. At the end, my friend tossed off something to the effect that, of course Bobby, the perenially single main character who couldn't find satisfaction with any woman, was really gay, although nothing at all in the text of the musical ever mentioned that.

I had never heard anyone say anything like that before, but I got it immediately. The famous closing number of that musical, which had already been famous for a decade when I saw it, was "Being Alive." In this song, Bobby calls out to a lover he hasn't met yet, a lover he can only imagine, longing for an aliveness his world of straight married couples doesn't offer. To the straight viewer, *Company* looked like the story of a confirmed bachelor finally growing up. But the queer viewer knew what "confirmed bachelor" really meant. Moreover, queer viewers could enjoy both stories at the same time. I saw that there were actually at least three stories on that stage: the story of straight Bobby, the ladykiller; the story of gay Bobby, trying to wake up to himself; and the story of this

Stephen Sondheim person who had written a popular musical that way. Why would he do that? Did he know that was what he'd done? In those days, being able to read for subtext was a survival skill that also made things very interesting: there were multiple, sometimes contradictory, dimensions to what you saw, if you knew how to see them, like Sandback's revelatory string. The alchemy of coming out worked both ways: you looked different to the world, but the world also looked very different, and much richer and weirder, to you. It was like having magic glasses. I must admit that, while it's certainly better for queer people in the United States now and that's good, I'm still a little ambivalent about sharing the magic glasses with straight people. These ways of seeing were psychic life and death to us. If you only understand them as technology or costume, you don't understand them. And why should straight people get them anyway? Don't they already get enough?

Coming out in a time of so much invisibility also taught me that if you headed out of what you knew, even if everyone said there was nothing out there or that what was there was dangerous, shameful, ugly, or sick, a door might well open onto something beautiful, alive, and, as you discovered, essential to your being. If you left the lights of the town, as it were, and headed toward the desert, incredible people and other creatures would be there to meet and delight you in all sorts of ways.

I have long said that the experience of queerness, in the time when I was coming out, prepared me beautifully for being a writer. Like being queer, being an artist means that you are continually insisting on doing something that maybe no one wants you to do, that very possibly isn't going to work, that's only going to end in defeat and humiliation, and that is unlikely to bring worldly rewards or general approval.

If the mode in my set was to look like you could build a cabin in the forest with your bare hands, that was because it seemed like you might have to, metaphorically, or maybe literally, if you wanted to

be alive. We wanted, very much, to be alive. If you had made it into that cab, you were one of the ones who wanted to be alive. Our unspoken pact was that we would, against all odds, make one another alive. We were also, individually and collectively, sort of a mess. That was in the cab, too: our shadow selves, all tooth and claw and narrowed eyes. People with that much appetite, facing that much barbed wire, can develop very sharp teeth.

My shadow self was mostly terrified. I wasn't scared, though, of the world, not really. I was scared of some unnameable inner current, something that often grabbed me by the throat from within, without warning, making my heart pound, shaking my veins. I didn't know what this was, I couldn't predict it or stop it, and when it was happening it felt like Earth itself had been sliced in half. I wrote dense, gnomic prose poems where bad things seemed to be happening far beneath the surface. My plan was that the prose poems, and the meridian of my desire, would lead me into some blazing new world. Freedom, on the page and in bed, would save my life. I was sure of it.

In the summer of 1981, after the miserable girlfriend dumped me, I met a tall woman who wore button-down white shirts and jeans every day, smoked underhand, had a New York accent, and was frequently mistaken for a man. At the Duchess one night, I asked her to dance. Then, after a long winter of feeling lost and betrayed and as though I couldn't find my way no matter what I did, I finally knew where I was. I knew exactly. As we lay in bed all that summer, the song wafting up from car radios was Stacy Lattisaw finding love on a two-way street. I didn't imagine that we were going anywhere specific on that or any other street, in the sense of being a couple, going toward a future, accruing social value and items from our wedding registry. We were just running in the direction we wanted to go.

===

Because Setterfield speaks of Merce Cunningham with so much love, I ask her why she left the company in 1975. She says that she left because Cunningham, who had been "so staggeringly present" onstage in the sixties, "stopped being in things so much" and "the adventure and the making of events and the moments that were unplanned and unexplained weren't happening in the way they had." The sets, designed by Robert Rauschenberg, Jasper Johns, and Andy Warhol, became fancier, as did the audiences, who often came as much to see the sets as the dances. The dance programs became fixed and repetitive.

Leaving Merce, however, was preceded by another major event in Setterfield's life. In 1974, at forty, Setterfield was a passenger in a car on Long Island that, while crossing railroad tracks, was hit by a train. The train dragged the car until it hit a telephone pole. Setterfield went partly through the windshield. It was weeks before she could sit up by herself; even once she could walk again, she was terrified of doing anything alone, because she would often find herself somewhere with no memory of how she'd gotten there. She was slow, and she didn't know what, if anything, she could do onstage. She had decided before the accident to leave the Merce Cunningham Dance Company, but now she wasn't sure if she was a dancer anymore at all.

To help her regain her confidence, her husband began to make a dance with her for the two of them called *Chair*. The dance began when Gordon pretended to fall off a wooden bench in Cunningham's studio and Setterfield laughed. Gordon was thrilled. In the days that followed, he coaxed her to sit on the chair, step on the chair, lift the chair, jump off the chair, even, into a pile of coats, fall off the chair. She moved. Her memory improved.

In a grainy video of a 1978 performance of *Chair*, the stage is bare except for Setterfield, Gordon, and two metal folding chairs. Their clothes are nondescript—shirts and loose pants, with matching white bands (like bandages?) at their knees. They each move

on, around, over, under, beside, atop, against, and even within the two folding chairs on which they also sometimes sit down. It's like watching the definition of a preposition written in choreography.

The chair is always there; the marriage, too, has always been there: a lifelong duet. They met taking a class with James Waring in 1958. When they were partnered, Gordon complained, "She's too heavy to lift," to which Setterfield replied, "He doesn't know how to lift." They were married for more than sixty years, until Gordon's death in 2022. In *Chair*, Gordon doesn't lift Setterfield; instead, he helps her remember how to lift herself. The metal chair also holds her, crowns her. If she needs it for support (does she list at one point? I peer at the blurry image), you can't tell; it looks like a virtuoso's prop, like the hat rack Fred Astaire danced with in *Royal Wedding*. In the video, Gordon is a looker—in photos from the seventies, he is something like Oscar Isaac crossed with Jake Gyllenhaal, flowing of dark hair and beard, sleepy of eye—but it is Setterfield who commands attention. She seems to be fully apprehending the chair in its mysterious essence, possibly molecularly, at every moment, and then making a choice about how to interact with it. Roll on it, maybe. Fold it up. Stand on it. Ignore it. She is more often downstage than Gordon, foregrounded. She appears to hold back nothing.

From *Chair* onward, Setterfield went down a path that wound through the work she made with Gordon combining dance, theater, and music; and to film roles with directors such as John Patrick Shanley and Woody Allen. Acting entered her oeuvre to stay. Gordon wrote pieces for her in which she played Marcel Duchamp (*The Mysteries and What's So Funny?*) and Bertolt Brecht (*Uncivil Wars*). The through line to her work in these various media is simply her ever-undiluted, undiminished, radiant presence. She is staggeringly present, and that never changes, not even when she is talking to me through the plasticky scrim of Zoom.

What went on in this marriage of two such charismatic people

whose lives and work were so deeply entwined? Whose house was a rehearsal space, and vice versa? (Also: the hot tub.) The more I think and read about Setterfield, the more I find that I can't apprehend her without Gordon. Obscuring my view, however, is the grid through which they were seen at the time: he was the artist, the choreographer; she was the art. In filmed interviews with Gordon and Setterfield, Gordon does quite a bit of the talking while Setterfield looks on. Often, this is because the interviewer is asking Gordon most of the questions. But every time the camera moves to her, the pressure in the mise-en-scène seems to change to accommodate the volume of her being. Gordon fills the space with sound and motion; Setterfield fills the space with her gaze. When she speaks, she speaks slowly, deliberately. She is in no rush, as if she knows that we will wait to hear whatever she has to say.

When I ask Setterfield about the marriage a few months before Gordon's death, she says, "I'm sorry that he has no care or interest in it. He just wants it to be over."

"What is 'it'?" I ask.

"Life," she says with her usual directness. "He's had enough." She, clearly, hasn't. It's hard to believe that the man whom Croce once described in the *New Yorker* as "shaggy in texture and sensuous in movement, with an overall look of ovals slipping within larger ovals," an engine of writing, dancing, connecting, and creating, could have had enough of life. On that day, Setterfield changes the subject, saying, "I don't like speaking about him as much. This is where we diverge greatly in our way of dealing with things." She begins to tell me about an interview with Nathan Lane she saw. She tells me what it was like to be in Duchamp's house, to meet his adopted son, the thrill of holding Duchamp's shoes in her hands.

In other words: she wasn't going to tell me. I look for clues elsewhere. For instance, in a talkback at the end of a performance of *Uncivil Wars* in 2009, the interviewer asked Setterfield what she responded to in Gordon's work as a director. She replied, "It upsets

all my apple carts. Always, I have looked for people who do that." In a 2012 conversation at Barnard College, Gordon said, "I'm always wooing Valda Setterfield. I'm forever wooing Valda." I feel certain that galaxies of complex interactions, onstage and off, must stretch between those two statements.

I can imagine many things, but here's what I can say for sure: this is a man who made a dance for a woman, a dancer, after she was hit by a train, and put her in the foreground of the stage; this is a woman who danced that dance with her complete attention not long after her head went through a windshield. As it happened, when Gordon died, it was the day after their sixty-first wedding anniversary.

For more than sixty years before that day, they had each other: on, around, over, under, beside, atop, against, within. This was the ground she chose on which to build her freedom.

Garden

Darrel Morrison, born in 1937, grew up on a 160-acre farm in Iowa. His father liked to sketch. His mother painted china. Morrison describes himself as "sort of a sissy" who was bullied as a child. He didn't play football. He played piano, arranged flowers, and made a newspaper called the *Cat Press*, inspired by, and often devoted to the doings of, the barn cats on the farm. Like all the other kids, he was part of corn detasseling crews in the summer. He loved to see the storms approaching over the plains, and the light afterward. He liked the smell of greenhouses. The family listened to the radio at night. Like his two brothers, he was given his own piece of garden by his parents. One day while milking cows, he had a vision of what his life would be: he would have a little brick house, with a picket fence and flowers all around.

Even at seventy-eight, talking to me on a snowy day in his apartment on the Upper West Side, he has a midwestern burr in his voice and a manner that is both friendly and reserved. He is handsome, jovial, curled up on the sofa in his socks. "You know I'm gay," he says to me right away, as if to warn me. There are boxes piled all around, because he is leaving New York to go back to Madison, Wisconsin, where his ex-wife lives in their old house. When he's in that city, which he will be now permanently, he has breakfast with her regularly. They had two sons during their twenty-four-year marriage.

One works for the State Highway Patrol in Wisconsin. The other teaches Mideastern political science and law outside London. Morrison is a revolutionary in landscape design. He changed the field (as it were). The mainstream American tradition that he saw in magazines like *Better Homes & Gardens* when he was a teenager came from England via Harvard. The curatorial principle was not unlike that of a zoo or a museum: plants came from everywhere in the world and were grouped together by experts. They were arranged to form exquisite visual compositions on lots and lots of lawn, not for any organic relationship to their environment or one another.

Morrison had a different idea. He entered the Adair County Fair flower-arranging contest at fourteen with carefully constructed displays of corn tassels, oat stalks, and alfalfa, because, he says now, "I thought they were neat." He swept the show, to the consternation of the midwestern ladies who were his competitors and his father, who was so embarrassed that he never said a word about it. But Morrison had found his vocation. He majored in landscape architecture at Iowa State, graduating in 1959.

Inspired by the prairie restorations of the 1930s, Ladybird Johnson's highway beautification projects, and new thinking about plant ecology, Morrison had a vision of what he calls "sweeps." Traditional landscape design then was dominated by "spots": those visually exquisite, often ecologically fragile single species from all over the world framed and isolated on lawns. Call it imperialistic gardening. Instead, Morrison loved the broad patterns, the light, the drifting that occurs in a natural landscape like the prairie. That was beautiful to him. If you've, say, walked on the High Line in New York, you've walked through an environment of sweeps— various native plants growing in swaths and clusters and handfuls. This kind of landscape design is everywhere now, but it wasn't in 1972, when Morrison debuted his design for the Women's Co-op Garden in Walden Park in Madison, Wisconsin, of oats, prairie

grasses, and native forest species. He was still married; as he tells me, "I played the suburban husband role really well." Despite a few conference dalliances with men, he stayed married until 1987. He came out in 1993, at fifty-six, by which he means that's when he told his sons.

After he came out, music began to play a bigger part in his process. If you were fortunate enough to be a student of Morrison's then, he would have told you to take off your shoes, pick up a pastel, and sketch landscape designs however they came to you while listening to Philip Glass's "The Low Symphony" or "Nessun Dorma" from *Turandot*. The new freedom he felt personally seemed to turn up music's effect on his creativity. He saw more "rivers" and "drifts"; his plans became more detailed, with dots of color throughout that flowed and ebbed into other colors. Even these drawings, done in colored pencil, seem to pulse.

It was as if, freed from a certain vector of secrecy, his capacity for synesthesia opened up. If you go to Storm King, the five-hundred-acre outdoor sculpture garden in New Windsor, New York, you can walk among the sweeps of switchgrass, oats, perennial alfalfa, and other native grasses planted by Morrison. The massive sculptures by artists such as Andy Goldsworthy and Mark di Suvero, lapped by native plants, seem like structures or beings from the future, or perhaps the distant past, by contrast. Or you can go to the New York Botanical Garden in the Bronx, and make your way to the Old Stone Mill, where Morrison transformed a one-acre site into, as he describes it in his book, *Beauty of the Wild: A Life Designing Landscapes Inspired by Nature*, "rivers of purple lovegrass and little bluestem . . . various ferns, wild geranium, columbine, woodland phlox, and sedges. . . . The drifts cascading down the slope were composed of closely spaced gray birch and sassafras trees . . . gray dogwood and dwarf bush honeysuckle." These environments never tell you where to look; they never point or isolate; instead, they flow, tumble, tickle the knee and the hand.

Throughout Morrison's life, always, has been the earth. Ground. Except for his early days as editor in chief of the *Cat Press*, he has never wavered in his vocation. When we talk about the role of love in his life, he includes "biophilia." In *Beauty of the Wild*, he writes that he has brought "a miniaturized version of a dry prairie into a series of cedar planting boxes" onto his apartment terrace in Madison. "So I am never far from little bluestem, purple prairie clover, mountain mint, and another thirty species of native prairie plants." A twenty-acre plot in Wisconsin that he bought in 2000 thinking he might build a retirement home has become the Morrison Prairie & Forest Preserve, populated only by native plants.

When I talked to him on that snowy New York day, I found myself thinking of Colette, who had a similar relationship to plants over her long, varied, and sometimes quite dramatic life. On the summer day that I visited the Colette Museum in Saint-Sauveur-en-Puisaye, her childhood village, the main exhibition devoted to her life was organized not by her books, but by the eras of her major relationships: Henry Gauthier-Villars (Willy), Mathilde de Morny (Missy), Henry de Jouvenel, Maurice Goudeket; there was also a section for her daughter, Colette de Jouvenel. One does wonder if the life of a major male writer would be similarly organized, although it has a certain psychosexual charm. (And what would curators do with Henry James? Henry Miller?)

However, if the curatorial principle was passion, the curators might as plausibly have organized her biography according to the green places in her life: the beloved garden of her mother, Sido; Casamene, the garden at the farmhouse in Jura she shared with Willy; the Bois de Boulogne; the garden of several acres she made, at fifty-two, at her house in Tamaris les Pins in Provence; the regimented garden of the Palais Royal that she watched every day from her window in the last years of her life, marooned on the sofa by arthritis. While we think of Colette as a writer who explored mat-

ters of the heart, her fiction is also full of all the stuff of the natural world: bodies, animals, dirt, food.

In *Flowers and Fruit*, published in 1986, the editor and Colette devotee Robert Phelps collected many of Colette's nonfiction essays on plants. Most of them were written on that sofa; reading them, one has the sense that she is summoning, through words, gardens and wild places where she will never walk again. Of a wisteria from her childhood she writes:

> It was as heavy with bees as with blossoms and would hum like a cymbal whose sound spreads without ever fading away, more beautiful each year, until the time when Sido, leaning over its flowery burden out of curiosity, let out the little "Ah-hah!" of great discoveries long anticipated: the wistaria had begun to pull up the iron railing.

In this passage, and throughout these essays, Colette glories in the powerful libidinal force and myriad strange beauties of plants. She feels pity for flowers "imprisoned" in flower shows and is suspicious of gardeners and others who try to bend the vegetable world to their preferences for impressive color and size. She calls a hydrangea bred for huge blooms "hydrocephalic." To the hellebore, she writes, "When you are put into the hands of the florist, his first concern is to manhandle your petals, bending them back flat, just as he attempts to do to the tulip, torturing it to death. Behind his back, I undo his work of breaking and entering."

Colette anthropomorphizes vegetative citizens constantly. Some badly treated anemones arrive at her flat "dry-eyed" and "prostrate," but once she gives them a "footbath" each anemone, feeling more "like itself," becomes "a surprise of red velvet." To a tulip, she writes, "Come and sit here by my side." She writes a monologue from the point of view of a gardenia, who appears to be having an ongoing rivalry with a nicotiana nearby. Meanwhile, in her

descriptions of people in her work, she—what would the word be?—vegetopomorphizes them. Renée, the main character in *The Vagabond*, sees her rouged cheeks in the mirror "as brightly coloured as garden phlox"; the cheeks of the young man Chéri in *Chéri* are transparent as "a white rose in winter"; necks are compared to lilies; a young male lover is seen as a rare, flowering cactus.

Had they ever met, in some parallel universe where Morrison went to Paris at fifteen and sat by Colette's sofa a few years before her death, they might have understood each other by the way they both regarded plants. Whatever language barriers would have existed, they could have looked together at Colette's beloved botanical illustrations by the renowned Pierre-Joseph Redouté. I think they would have laid their hands together gently on the prints—his smooth ones, her veiny and gnarled ones—as if they could touch the living things themselves:

"Le lis."

"Lily."

"Primevère."

"Primrose."

"Glycine."

"Wisteria."

———

I am writing this as summer heat explodes records; in Portland, Oregon, it's 115 degrees and streets are buckling. Glaciers are melting. Species, possibly including ours, are approaching extinction. The black-and-white cat, unaware (or is he?), sleeps on my desk. I am neither bedridden nor arthritic, nor a national treasure, and my study window overlooks a concrete courtyard, not the Palais Royal. But what Morrison and Colette saw years before I was born—that the natural world needs to be cultivated, loved, and defended—I see now, possibly too late. Their aesthetics are inextricable from their

sense of themselves as being composed of the sensual world. "My poetry is earthbound," Colette once wrote. She isn't writing toward heaven, in other words, but to and from embodiedness. These two gardeners are lifelong artist-scientists, and lovers. Morrison, in his fifties, fell in love with an Italian plant scientist, a man whom he met at a concert at the University of Georgia; then, later on, a Brazilian man named Flavio, who died; then others. In Colette's novel *Break of Day*, the fiftyish heroine—who is also named Colette—retreats to her summer house in Provence to renounce love for the rest of her life. Colette wrote the book after her second marriage, to Henry Jouvenel, ended. It was published in 1928, when she was fifty-five. Lyrical and elliptical, suffused with profound pleasure in the natural world, the novel can make the reader believe that connecting to plant life isn't only a substitute for sex, it might be a bit better. On a walk along a coast road, fictional Colette communes with "the narrow flowery marsh where hemp agrimony, statice and scabious contribute three shades of mauve, the tall flowering reed its cluster of brown edible seeds, the myrtle its white scent—white, white and bitter, pricking the tonsils, white to the point of causing nausea and ecstasy—the tamarisk its rosy mist and the bulrush its beaver-furred club." Who needs human beings when nature is this polymorphous and sensual?

In life, however, Colette was already deeply, ecstatically, involved with Maurice Goudeket, seventeen years younger, who became her third husband in 1935 and to whom she stayed married until her death in 1954. In *Break of Day*, fictional Colette renounces the highly delectable, much younger Vial, who spends his days restoring furniture, swimming, not wearing a lot of clothes, and pursuing her. To his ardor, she replies, "*Au revoir*," without so much as a kiss passing between them. Real Colette did no such thing. Taken together, real Colette and fictional Colette are like phases in the life cycle of perennial plants. They bloom, go fallow, bloom again. After a loss, we may well seek release and renewal in the nonhuman

natural world. And then we reemerge. Fictional Colette was sure she would never love again. Real Colette loved again.

If my question is, What sustains artists over the long run?, then the answer from Morrison and Colette might clearly be: earth, which sounds so charming. However, one can't garden, or be in a garden, or a forest, or on a prairie very long before one notices the death. Unlike statues or cathedrals, plants inevitably turn brown, wither, and die, some of them quite quickly (coquelicots, those vibrantly red poppies that exhilarate the summer fields of Provence), others extremely slowly (redwoods). It is often said of Colette that she was a connoisseur of love, but it could equally be said that, more than once, she was able to bear and create from the death of love. And the return of love. As the museum in Saint-Sauveur-en-Puisaye demonstrated, her life comprised a series of long, intense, generative relationships that opened and then closed. Morrison speaks lovingly of his ex-wife, his ex-lovers; he isn't in love now, he says on that snowy day when I interview him, but he wouldn't mind another romance.

Every garden is also a graveyard. Every book or painting or piece of music both resurrects what has been lost—this family trying to get to a lighthouse, that August light, that perfect day—and marks its absence. Colette's comparisons of necks to lilies and young men to cacti is more than lyricism. It is reality. Eventually, all people do become plants. Architecture often gets worse as it ages, Morrison says, but a landscape properly done only gets better, by which he means less visibly "designed" or what he calls "frozen." He likes to tell students that painting is two-dimensional, sculpture and architecture are three-dimensional, but landscape architecture is four-dimensional and the fourth dimension is time. He enjoys watching the pattern of his plantings get "fuzzier" over the years, an aesthetic that might apply equally to our inner lives, our perceptions, our bodies, and our artistic work. We all know what it means when, say, a famous performer gets installed in Las Vegas to reenact a particu-

lar, hit-making version of themselves night after night, and perhaps there is a freedom in that kind of transactional clarity. But it also confines the experience to nostalgia on both sides of the stage, and it carries the faint musty scent of Miss Havisham's house. By contrast, I am moved by Matisse's cutouts, which he made late in life when mobility issues made it difficult for him to paint, because they are beautiful, because he was continuing a lifelong artistic conversation with himself about color, and because his hand, in this late work, seems so much closer. Monet painted his famous impressionist water lilies that way because his vision was failing, but with that failing vision, he showed us more about light and the nature of seeing itself than crisper images would ever have done.

Over time, and with the action of time, we see differently. Why would crispness be more "true" than fuzziness? Both are true; neither are true. As Diana Vreeland said, the eye has to travel, and over the long run perception inevitably changes. If we are to, say, save the planet, we might have to consider the difference between valuing the immortally frozen (plastic, visual images on screens, money) and valuing the mortally mutable (plants, animals, us). One wonders if our fear of death, which is to say decay and aging and limits on resources, might actually be what ironically causes our extinction, more than the usually cited sin of greed.

=

I am not a gardener. My current partner is a gardener; he knows intuitively what plants want, which seems to me like a superpower. My garden has been this city, New York. I have been on, around, over, under, beside, atop, against, and within it nearly all my life. I now live less than ten blocks from the hospital where I was born over sixty years ago. I have loved this city, hated it, been bored by it, indifferent to it, amazed by it, hurt by it, changed by it, and always, always, I have come back to it. New York is abundant in both sweeps

and spots of people and things, in life both cultivated, sometimes tortuously, and growing wild. I don't think it is, as San Francisco calls itself, "the best place on earth." There are cities far more beautiful, more livable, more generous. In Chicago, they seem to measure apartments in how many heads of cattle could be stabled there. In Berlin, a raw intelligence suffuses every square inch. In Istanbul, the multiple daily calls to prayer make the city incandescent. There are less populated places to live where body and mind thrive, so much closer to the natural world. New York isn't the best place; it's only my place. Over forty years after returning here on the cusp of adulthood, it's impressed so deeply into my bones that it doesn't matter what iteration of New York I first fell in love with. We belong to each other.

If you live in a place for a long time, it, too, becomes a graveyard, with memorials everywhere. This is the movie theater where I last ran into him before he died; here is where I attended the memorial service for her; that's the building where he had been living, so ill, on the morning I called, too late. Your past lives, past selves, haunt it, too. You are still going to dinner with that lost friend or lover in that great little restaurant that no longer exists, crying on that sidewalk, dancing in that fabulously sexy-grimy club that is now a boutique that sells very expensive sneakers, laboring away at that desk high up in a corner of what has become a multiplex, marching down Sixth Avenue with thousands of others to protest things that happened anyway, interviewing that star you worshipped in that hotel room. The star is dead; the hotel is still there. Year after year, the layers increase; your past selves multiply. They crowd the avenues, terribly busy. And that's not even counting the dogs and cats whose ashes you could never quite bring yourself to scatter. The white boxes pile up on shelves. (Won't they be lonely without me?) In his novel *The Sun Collective*, Charles Baxter writes that, to a man in a marriage of many years, his wife is "like water: you didn't have to love water when you were thirsty. You just needed it to live."

New York is my water. My books haven't been "about" it; they have been of it, because I am of it.

At the same time, I'm aware—and even more so as I age—that New York will clatter on perfectly well without me. This is true of any source on which we depend. The earth long predates, and may postdate, our species; the city blazes along no matter the citizens; if you marry, the bond exists legally whatever anyone may be feeling at any given moment. We cannot exist without the source, but the source can exist perfectly well without us. In the same way that I envy gardeners, I have also envied people of deep religious faith, because they know that they are part of something so much bigger than themselves that is kindly disposed toward them, and they can lean back against that. If I believed in Jesus, maybe I wouldn't have to live in New York.

As it is, I draw spiritually every day on the abundance of this city. While there are many kinds of abundance here—cultural, racial, financial, architectural, culinary—the one I love most is the narrative abundance. Walk onto a subway car—any subway car. Look at the people: the Latinx woman with the four black balloons (why?); the two very pale young men in short-sleeved white shirts with name tags that say Elder Smith and Elder Anderson (How could they be elders, barely able to grow their first beards? Elder Anderson's name tag is tilted); the Black man in a suit wearing hot pink earbuds, watching on his phone as someone does a handstand against a wall (a friend? an instructor?); the lanky, elderly white woman who refuses all the seat offers of the Elders, the Black man, and the Latinx woman. She holds on to the pole with both of her large hands, looking around at everything, full grocery bags at her feet. (Is she new here? Where is she from?) The train rushes past station platforms where more stories mingle and wait, peering down the tracks. The train also rushes past ghost stations: dark, abandoned caves covered in graffiti. Who hovers there, still? Do I see a face there, or do I imagine it?

I don't know what all these stories might be, only that they are there, innumerable, endless story in all directions, and at all hours. You can read this city for your entire life, and never get to the end of it. It is an enormous novel, a vast collective roman-fleuve, and you don't even really know what role you may be playing in it. The rivers and drifts, the sweeps, carry you along with them, furiously paddling away at your life, thinking you're an isolated dot, often entirely unaware of the greater current. The shaped narratives on offer here in print or on film or on the stage or in museums can be extraordinary, but equally extraordinary are the unshaped narratives that grow wild on every street and that you might glimpse in a window, in a car speeding past, in the doorway of a building, leaning on a folding chair. It is this plenitude and mystery that I love—not only the stories I know but also perhaps even more all the stories I can never know, only sense, fleetingly, as they pulse around me and then move on.

═

In her last major work, the memoir *The Blue Lantern*, published in France in 1949, when Colette was seventy-six, she is more or less confined to that sofa overlooking the Palais Royal. She is in pain, and mourning the deaths of many whom she loved. Still, she is as alive to the room around her as she once was to the wide world. She writes that she has been watching "for the last month a seed pod—from some exotic plant, no doubt—the capsules of which retain for a while and then expel, almost with violence, a delicate silvery follicle weighted with a tiny seed and lighter even than thistledown. One by one these feathery tufts break loose, drift up to the warm air beneath my ceiling, float there for some time before descending, and should one of them happen to be caught by the draught from the fire it yields at once, a consenting victim, and flings itself deliberately into the flames, there to perish of its own volition." She

doesn't know the name of the plant, but it's hard to feel that that matters when she has such a strong sense of its soul.

===

On a July day that isn't life-threateningly hot, but hot enough, my partner and I take the train to the Brooklyn Botanic Garden, where Morrison created the Native Flora Garden extension in 2011. We have a map of the garden, but we get confused anyway. We make our way to a shady glade where placards explain the Native American names for each tree and what it was used for (medicine, canoes, gifts); is this the extension? We go through a wooden gate: Are we going into the extension now? Or did we just leave it? It's a Saturday, so this green space is busy. Everyone on the pathways is wearing their masks at wrists and elbows, like corsages. Some of them are talking loudly to one another or into their phones. We can hear traffic noise, radio noise from the street outside. A plane passes overhead.

"Look," says my partner. "An inchworm."

Butterflies. Bees. A dirt path. It's getting brighter. I put my hat on. We cross a little bridge, and now it's all sun, color, and tall, brushy stalks. This must be the extension, because it feels like we've wandered into an unplanned meadow. It's very fuzzy. In some places, the path is nearly overgrown by the tall stalks, which swish against us as we walk. I find I am walking more slowly. It's quieter back here. I call it a meadow but it's actually pine barrens, native to the Northeast, and what Morrison, in *Beauty of the Wild*, calls "a symbolic white cedar–blackgum–red maple swamp, symbolic in that it has some of the key representatives of a pine barrens swamp but is only a tiny vignette as opposed to a true restoration of one." We don't feel that we are in a symbol, though; we feel ourselves extend into these trees and plants, into the warm, brushy blur of them. If I were Morrison, I could identify some of the scents as "the curry-like smell of rabbit tobacco and pungent beebalm," but I just think:

hot earth. I remember something from my childhood, something that felt and smelled like this, and the way I felt then.

Later, we sit in the shade of a grove of identically spaced trees on a lawn, next to a rose garden. Nearby, two women in headscarves take each other's picture. A group of people, young and old, are two trees away on several blankets. Fragments of their conversation in Spanish float through the warm air. I don't know what we look like to them—an older white man and white woman, both in white shirts, who obviously haven't come prepared for any kind of picnic. The man has a shaved head and the woman wears a straw hat. If we were in one of Darrel's planning watercolors, we'd be fuzzy beige spots on green lawn.

"We should come out here more," I say. "It's amazing."

My partner takes off his shoes and socks and stretches out on the grass. Eyes closed, arms outstretched, he nods, already drifting away.

Desire

I am getting it wrong with Samuel R. Delany—Chip, to everyone who knows him. I call him Chip, too, because I feel that I know him. Do I, though? When I venture that his personal life has been remarkably stable, he says, "Perhaps it seems more stable than it was." When I ask him about a gap in his creative life between 1968 and 1973 and refer to a man he knew around that time as a lover, he corrects me. That man was never his lover. It wasn't a gap; he was finishing two major works. He quotes Rilke: "Fame is the sum of all the misinformation current about you." When I correct my use of the word *stability* and offer *connectedness* to those he loves as a foundation in his life, he cites, instead, "the interest of the [sci-fi] community," and continues, "To me you seem to have a very odd notion of the connection between the life and the work." He prefers to answer questions by email, so he writes all this to me in what seems a very easy, amiable tone, but I am simultaneously embarrassed, frustrated, and anxious. This is a queer writer, a person from my home planet, and I fear not only that I'm offending him, but also that I'm not going to be able to write well about him at all.

I begin looking at the basics. In 2011, Rachel Kaadzi Ghansah interviewed Delany for the *Paris Review*'s Art of Fiction series. She sums up his early life like this:

Delany was born on April 1, 1942, in Harlem, by then the cultural epicenter of black America. His father, who had come to New York from Raleigh, North Carolina, ran Levy and Delany, a funeral home to which Langston Hughes refers in his stories about the neighborhood. Delany grew up above his father's business. During the day he attended Dalton, an elite and primarily white prep school on the Upper East Side; at home, his mother, a senior clerk at the New York Public Library's Countee Cullen branch, on 125th Street, nurtured his exceptional intelligence and kaleidoscopic interests. He sang in the choir at St. Philip's, Harlem's black Episcopalian church, composed atonal music, played multiple instruments, and choreographed dances at the General Grant Community Center. In 1956, he earned a spot at the Bronx High School of Science, where he would meet his future wife, the poet Marilyn Hacker.

Delany seems to have been a prodigy, but unlike many prodigies, he has continued to thrive over the many decades of his career. His oeuvre is nothing short of monumental. He has published over forty books, many of which are sui generis works of science fiction, but he has also written numerous memoirs, works of literary criticism, graphic novels, and two issues of *Wonder Woman*. *Dhalgren*, his 1974 speculative opus of over eight hundred pages, has sold more than a million copies. He has made at least three films, and one film has been made about him: *The Polymath, or The Life and Opinions of Samuel R. Delany, Gentleman*, directed by Fred Barney Taylor, which came out in 2007.

The many books, essays, and scholarly studies written about Delany often refer to him as a genius. William Gibson, Umberto Eco, and Jonathan Lethem, among many others, have spoken of him in worshipful terms. In *The Polymath*, Walter Mosley calls him "one of the greatest men in American literature, period." He has won four Nebula Awards, two Hugo Awards, and the Sir Arthur

Clarke Imagination in Service to Society Award for Outstanding Contributions to Fiction, Criticism and Essays on Science Fiction, Literature and Society. He also has, in his words, "extreme dyslexia," and, with his long white beard and round belly, bears more than a passing resemblance to Santa Claus, or, in more recent years, Noah.

He has had sex with, he estimates, "well above 50,000 people." His daily routine in the days before AIDS, as he has described it, was: "Sit at the typewriter from 8a until 10a or so. Go to the public bathrooms in Tompkins Square Park and have intercourse with six or eight strangers. Return home. Write for two more hours. Go to another park, and another bathroom, and do more of the anonymous nasty. Return home. Write a bit more . . ."

None of these impressive numbers and facts, however, convey what it is like to enter his immersive body of work. In a 1996 foreword to *Dhalgren*, Gibson describes the book as "a prose-city, a labyrinth, a vast construct the reader learns to enter by any one of a multiplicity of doors. Once established in memory, it comes to have the feel of a climate, a season." It begins in the middle of a sentence ("to wound the autumnal city") and ends on an incomplete one ("Waiting here, away from the terrifying weaponry, out of the halls of vapor and light, beyond holland and into the hills, I have come to"). In between is a phantasmagoric, postapocalyptic explosion of text with no small amount of sex that has been compared to James Joyce's *Ulysses*. Delany can, and should, be read alongside maximalist superbrains such as William Gass, Thomas Pynchon, and Don DeLillo at his most *Underworld* verbose.

Science fiction, as it was called in the years of Delany's early career, often features a lot of great world-building, but very little unresolvable mystery. Even now, as a genre, it can be pretty chaste and straight. When you go through one of those multiple doors into Delany's fiction, however, you will be riddled, spun around, left wondering, and wandering, across otherworldly terrains you may

never understand fully and in which many kinds of sex, and sometimes sexual violence, are an essential part of the trip. Delany's work is, indeed, trippy, omnivorous, and X-rated. To a genre that could seem to traffic heavily in cardboard cutout heroes and aliens made of vacuum cleaner hoses and Styrofoam, Delany brought the fire of modernist form-breaking and pornographic exuberance. He was also an African American man, and a queer one at that, in an overwhelmingly white field. When Ghansah asks him Octavia Butler's question, "What good is science fiction to black people?" he replies, "Science fiction isn't just thinking about the world out there. It's also thinking about how the world might be—a particularly important exercise for those who are oppressed, because if they're going to change the world we live in, they—and all of us—have to be able to think about a world that works differently."

This thinking differently, from worlds to sentences, is what Delany does best. One of the pleasures of reading his work is the sense of being inside a vast, humming intelligence without hierarchies: everything, everywhere, fascinates him, turns him on, makes him want to write. He is in conversation with all of it, a kind of multidimensional city unto himself. In his 2021 nonfiction reflection on writing, *Of Solids and Surds*, Delany says, "You can put together more interesting combinations of words in science fiction than you can in any other kind of writing—and they actually mean something. You can say things like 'The door dilated' and it's not just a poetic metaphor." In the same book, he also says, delightfully, "A lot of my writing was done to stimulate myself sexually." (E. M. Forster said the same of a group of stories with explicit gay themes that he didn't publish during his lifetime; they were released posthumously in 1973 as a collection titled *The Life to Come*. In his diary, he said that he wrote them "to excite himself," making one wonder if autoeroticism ought to be added to ways to solve writer's block.)

If reading Delany's fiction is like falling down the rabbit hole, however, reading his nonfiction is like being taken on a tour by a

genial, erudite uncle who carefully points out all the sights and explains them in detail, yet with elegant brevity. Arguably, his most widely read book besides *Dhalgren* is *Times Square Red, Times Square Blue*, first published in 1999, in which he reports on and critiques the transformation of 42nd Street from the pornotopia he frequented with so much pleasure to the sterile, Disneyfied, family-friendly, open-air mall it is today. This book is made of passages like this one:

> At the Variety Photoplays you gave the elderly fellow inside his booth your dollar and, through the tiny window in the glass, he gave you a nickel change and your ticket from a large roll— weekdays yellow, Saturdays orange, Sundays blue. (Yes, it was 95¢ in the seventies, up from 45¢ in the sixties.) Always in a brown or blue suit and a red bow tie, he mumbled heatedly to himself nonstop. For years the theater had been a gay cruising ground. The (strictly heterosexual) pornographic movies started as a Saturday offering. . . . The tickets' color coding allowed them to compare the take from days when sex films played and days when legit features ran.

Not only do we see that elderly man in the booth, bow-tied and mumbling, but we also get a view of the pragmatic economic mindset at play that kept places like these alive for as long as it did.

Delany frequently embeds his analysis in witty observations. In the early eighties, in response to an outraged Times Square tour led by Women Against Pornography, he conducted a tour of his own. He reported that

> I did an informal tabulation of six random commercial porn films in the Forty-second Street area and six random legit movies playing around the corner in the same area during the same week. I counted the number of major female characters

portrayed as having a profession in each: the six legit films racked up seven (one had three, one had zero). The six porn films racked up eleven. On the same films I took tabs on how many friendships between women were represented, lesbian or otherwise, in the plot. The six legit films came out with zero; the six porn films came out with nine. Also: How many of each ended up with the women getting what they wanted? Five for the porn. Two for the legit.

The image of Delany trotting from theater to theater to do the count, in the guise of a latter-day Don Quixote tilting at what he saw as prudery, is both hilarious and trenchant. What he noted was right there on all those big screens for anyone to see, but only someone with his unique, unblinkered vision could see it. Since we're talking about porn, one might well assume that Delany's tongue was firmly in his cheek ("women getting what they wanted" is a flexible phrase, to say the least, as is the word "profession"), but that's too easy. He's kidding, but also, it seems to me . . . not.

The lines more conventional minds draw between and around things—experiences, identities, forms, genres, media, desires, genders—seem not to matter or even be visible to Delany. As Lethem says in *The Polymath*, "His most singluar facet is that he's multifaceted. He never saw the boundaries between, say, comic books and high art, literary criticism, autobiography, fiction. He never saw the formal restrictions between narrative and radical textual innovation. . . . He always embraced every contradiction that art offered and made it unified in his work." Moreover, the overwhelming impression of him one gets from the writing, the interviews with him, and his own extensive reflections on his life and work is of a happy man. He bears no grudges, grinds no axes, settles no scores. He's the least edgy revolutionary ever. There is, in fact, a gap in Delany's output of speculative fiction from the 1990s and early 2000s as he worked in other forms, but when I ask him about

this, he replies, "Going on from wherever I am into my next work is all I ever experience. . . . I don't leave and return. I just go on." Astonishingly, this seems to be true. How many people, let alone how many artists, can say this?

And yet. It is a strange thing, to stand before someone who has created so much, who has been so tremendously self-disclosing, who seems to hold back nothing, and still to feel that one is missing something essential. His books pile up on my desk, worlds upon worlds, but I can't get an angle. Something slides away, just beyond my peripheral vision. Maybe I do have an odd vision of the connection between the life and the work. And what can I add to the life story of someone who has told his own life story at such great length and with so much detail and honesty already? Questions like this came up many times as I wrote this book. David Gordon, for instance, constructed a vast web page called "Archiveography" that comprises a tremendous amount of material about Valda Setterfield and himself: photos, interviews, artists' statements, profiles, scripts, videos, and more, divided into decades, from the 1930s to the 2020s. It's exhaustive, but it's also more revealing than anything I could write about them. Is there anything more personal, more vulnerable, at the end of the day, than the artist's work?

In *Bread and Wine: An Erotic Tale of New York*, Delany provides the text in a graphic memoir drawn by Mia Wolff that recounts the early days of Delany's relationship with Dennis Ricketts, when Ricketts was still homeless and Delany used to see him selling books on West 72nd Street. The book is, indeed, graphic in every sense: here are Delany and Ricketts naked, fucking, but also here is Ricketts vomiting, and here is an image of the socks that had rotted to Ricketts's feet. In my interview with him, Delany recalls, unbidden, "I didn't like my father, and pretty soon I realized he didn't like me either. In my earliest years, he used to spank me— and [my] memory of them is pretty terrible. As he spanked me, he

would grow angrier and angier, hit me harder and harder. He would only stop when, I believe, he scared himself. On at least one occasion his beating—with a hairbrush—broke the skin and there was blood." *In Search of Silence: The Journals of Samuel R. Delany*, volume 1, *1957–1969*, runs to nearly seven hundred pages. *The Motion of Light in Water: Sex and Science Fiction Writing in the East Village*, published in 1988, is Delany's account of his life from the late fifties to 1966. He describes with great clarity his marriage to Hacker, his relationships with men, his early novels and how they were made, his psychiatric hospitalization, the threesome which he and Marilyn formed for a time with a man named Bob, his turbulent relationship with his father, and, with equal candor, the unreliability of his own memory, among many other aspects of those years. His account is breathtakingly thorough. His expressiveness almost seems to be at a 1:1 ratio with his life. What could I ask him that he hasn't already answered in full himself?

Or perhaps the more pertinent question is: What is it that I really want to know about Chip, or from him?

═══

Here's something I don't go into with him. I first "met" him over thirty years ago, in stories told to me by my lover, who was an ex-lover of his ex-wife, poet Marilyn Hacker. That lover, let's call her J, pulled up to my life in her Saab, tapping cigarette ash out the window on her way to the Oak Room to drink scotch. I got in. J and I broke up ten years later, so there is this daisy chain of exes between me and Chip. However, as in a game of telephone, if the word *desire* was first whispered, say, from Chip to Marilyn in the fifties, by the time J whispered it to me at the end of the eighties, it had changed shape radically. What similarity could there possibly be between that couple and the two of us? Chip and Marilyn met as teenagers at Bronx Science in 1958—both brilliant, precocious, city kids—

married across color lines in Detroit before either was even twenty (Michigan was one of only two states where they could be legally married), had a child, and came out (first him, then, later, her), while both published much-lauded books left and right. J and I were both white children of the suburbs; we met closer to thirty, neither of us having published one book; marriage wasn't an option; and as for children—maybe one, maybe later. To me, Chip and Marilyn were something like J's parents, although J's actual parents were very different. Chip and Marilyn were iconic bohemians, as outsized and magical to me as Easter Island statues, artistic progenitors rather than biological ones.

J told me that Marilyn had a big apartment on the Upper West Side. I was never there, but I imagined it as rambling and generous, with slightly tilted floorboards and the long central hallways common to that neighborhood, opening onto high-ceilinged rooms filled with books and records and pets and things scattered around by her and Chip's daughter, Iva, who was a teenager by then. Chip, said J, lived nearby in another big apartment with his lover, who had been a street person. Both Chip and Marilyn were geniuses, and they had once had Auden to dinner. From the beginning, they'd had an open, polyamorous relationship. Marilyn spoke fluent French and had an apartment in Paris. Chip's aunts were the famous Delany sisters, of the book *Having Our Say*, activists who both lived to be over a hundred and did yoga, which included standing on their heads, every day. I didn't meet Chip in person then, although I did meet Marilyn and Iva. He was like another planet that exerted a gravitational force on his ex-wife and daughter from somewhere in outer space not far from the West 80s. To me, they all seemed like the embodiment of the new queer family to which I aspired. The art, the freedom, the varieties of sex, the kid, the improvisatory lives, the worldliness, and, somehow, the means to do all this, not to mention the real estate: what could be better?

In my mind, we were all together under the sign of abundance. Abundance of language, abundance of books, abundance of sex, abundance of possibility, abundance of ambition, abundance of world, and of worlds. Abundance not only of appetite but also of satisfaction. Desires felt, desires met. If you think that what follows will be the slow, sickening thud of the realization that it was all an illusion, a tragedy, a disenchantment: no, sorry. Things may fall apart, and eventually they all do, but that doesn't mean they were never there in the first place. And abundance of quirks, neuroses, challenges, and losses sustained was part of it as well. Taking it to the limit, in all directions, was the point. No book, tradition, or practice was out of the question.

That scope included the most demanding aesthetic constraints. Like Marilyn, J was a formalist poet. They both wrote villanelles, sonnets, sestinas, pantoums, and crowns, among other forms, an ability that was as strange to me as being able to write code, or build a car engine. More even than an ability, or a talent, poetic form was a passion to J and Marilyn, deep game, a language whose meaning was somehow made of the form itself. Reading J's work, hearing her talk about poetry, I began to see how repetition and patterning could accrete meaning over the duration of a poem. A refrain that meant one thing the first time you read it could mean something else entirely the last time it occurred because of what happened in the intervening verses.

Consider the lyrics of the folk tune "Cockles and Mussels":

In Dublin's fair city, where the girls are so pretty
I first set my eyes on sweet Molly Malone
As she wheeled her wheelbarrow
Through streets broad and narrow
Crying cockles and mussels, alive, alive-O!
Alive, alive-O! alive, alive-O!
Crying cockles and mussels, alive, alive-O!

She was a fishmonger, but sure 'twas no wonder
For so were her father and mother before
And they each wheeled their barrow
Through streets broad and narrow
Crying cockles and mussels, alive, alive-O!
Alive, alive-O! alive, alive-O!
Crying cockles and mussels, alive, alive-O!

She died of a fever, and no one could save her
And that was the end of sweet Molly Malone
But her ghost wheels her barrow
Through streets broad and narrow
Crying cockles and mussels, alive, alive-O!
Alive, alive-O! alive, alive-O!
Crying cockles and mussels, alive, alive-O!

Molly's cry is ordinary in the first verse, broadens to include her family in the second, and is the mournful song of a ghost in the last; it is also the sound that haunts the grieving singer. That repetition of the word *alive*, which becomes ironic by the third verse, is the very sound of the speaker's grief. How peculiar. How revelatory. I wasn't writing then. I had stopped a few years before, after publishing my first short story, which so thrilled and alarmed me that I didn't know if I would ever write again. I was working as an editor at the *Voice Literary Supplement*, which was part of the *Village Voice*. I was good at being an editor, and maybe, I thought, this would be my path in life. I talked to brilliant and gorgeously eccentric people every day; I felt that I was in the center of everything that mattered.

So didn't I know already how repetition and patterning create meaning? After college and graduate school in English literature, then every day at work crawling word by word, comma by comma, through text and text about text and text about text about text, what did J's villanelles and sonnets tell me that I hadn't already heard?

But here we come to the course of my true education, which hasn't much taken place in classrooms. The first woman I ever slept with was reading Tillie Olsen's *Yonnondio*. I read Alice Munro because another lover was reading one of her books. The woman I asked to dance in the Duchess was reading Elizabeth Bowen's *The Little Girls* that summer; after she left me in the fall, I read that book, wanting to know what had drawn her attention. I've been a Bowen devotee ever since. A man I was seeing for a while just after I turned fifty was a fan of Yoko Tawada. The man left, but Tawada is with me still. J gave me a copy of Jean Stafford's *The Mountain Lion*, and for years thereafter we quoted lines of it to each other; I never pick up that book without smelling J, hearing her voice. For me, Stafford's lapidary style is inextricable from the joy and the terror of falling so deeply in love that I used to cry from the realization that one day death would part me and J. So deeply in love that after we had sex, when I fell asleep, I would dream about having sex with her. Once I read about Stafford's life in Ann Hulbert's 1992 biography— the drinking, the catastrophic relationship with the poet Robert Lowell, the cruelty she both endured and inflicted—that became part of my understanding of that novel as well: the lotus flower of the work growing from the mud of the life. J gave me that flower.

In addition to the other forms of eros, there seems to be, for me, an eros of the beloved's aesthetic. As William Maxwell once wrote in a letter to Sylvia Townsend Warner, when he was asked how he came to love Asian art, "I said rapturously, 'I got it second hand,' without thinking, but surely that is how all pleasure is got—from the rubbing off of somebody's else's pleasure in something. From eye to eye and skin to skin. A cousin of love-making."

When I did begin writing again a few years into being with J, it was the repetition and patterning of formalist poetry that I used to structure my first novel, *Tea*, which I imagined as three linked novellas titled "Morning," "Afternoon," and "Evening." The "refrain" was the suicide of the main character's mother; the intervening "verses"

were three different periods in the character's life as she grows up. I named the main character Isabel partly because the homonym of that last syllable—bell—called to my mind reverberations, sounds that linger nearly infinitely. The suicide was that ever-lingering sound. It happens when Isabel is a child, but its meaning changes over and over as she gets older. Every time she returns to the event, she interprets it according to who she is and how she thinks at that time. The event doesn't change, but its meanings continue to spiral with every repetition, never reaching a conclusive interpretation.

"Influence" is too light a term for this. I sank the foundations of my first book into a structure beloved to J and at which she was adept. *Hold this,* I might have been saying to her. *Hold it where you hold what is closest to your heart. Build this book with me.* At the time, this didn't feel like a choice. It felt like the way the book had to be written. It was how the vision of the book came to me, in a rush, waking up from a nap in J's loft bed one afternoon around 1992. From that moment on, I began making the choices that would transform me into the writer I am now. Again, only in retrospect do I see, or imagine, that I was choosing. At the time, much like meeting J, it felt like my fate. With a single-mindedness that suggests one who is walking a tightrope over an abyss and resolutely not looking down, I hurled myself at J and at writing as if my life depended on it. For years, I carried around a little notebook for ideas on the front of which I wrote the famous Kafka quote, "The book must be the axe for the frozen sea within us." Every day, I felt that I was swinging that axe at all that seemed unsayable, and I absolutely had to say it. Not long after I published *Tea,* J and I broke up, with maximum damage all around. All these years later, however, lines of J's poetry still go through my head. They are part of the DNA of my sensibility.

With a different lover, after J, I lay on the floor of a curtainless study in Chicago one night as traffic passed outside. "Look," this lover said. "See how the shadows move on the wall when the cars go

by? Isn't that amazing?" I fell in love with her not least because she was a person who could be entranced by the movement of shadows. Often, when I see a shadow shimmering on a wall, I think of her. For me, the book or the visual image or the music that has the scent of the beloved's attention on it has a kind of magnetic glamour. Those flashes of glamour have influenced the way I write more than anything I was ever assigned to read in any classroom or by any publication for review. Among other things, one might say that I have wanted to make work that would enchant the beloved as much as those books or images or music made by others enchanted them: a weird subvariety of jealousy.

In *Georgia O'Keeffe: A Portrait*, a book of luscious black-and-white palladium print photographs taken of O'Keeffe by her husband, Alfred Stieglitz, over thirty years, O'Keeffe writes in the introduction that, when the work was first shown, "Several men . . . asked Stieglitz if he would photograph their wives or girlfriends the way he photographed me. He was very amused and laughed about it. If they had known what a close relationship he would have needed to have to photograph their wives or girlfriends the way he photographed me—I think they wouldn't have been interested."

Though some of these photographs are nudes, I don't think that content is all of what O'Keeffe meant. For example, over the course of those decades, he continually photographed her hands. While her face ages, her hands don't seem to change; they seem to remain youthful, sculptural, often carefully arranged in gestures like mudras or in choreographed positions against objects. What did O'Keeffe's hands mean to Stieglitz, to photograph them this way? Who could possibly say? I would venture to guess that what she meant in the quotation is that the intimacy between her and Stieglitz was intense, untranslatable, and entirely specific to them. We can see the art that the intimacy between these two people made, like shadows on a wall, but we couldn't possibly know what passed between them that created those shadows.

It's funny, really. I teach writing for a living, but I could never teach my students the way I have learned best. Some teachers do, I suppose. But not me. By temperament or ethics, I can only give my students the dry imitation of what I might call aesthetic intercourse. It probably isn't enough. In the early nineties, not long after I got together with J, I took a class with Michael Cunningham, which began an intense friendship of more than twenty years. Like J, he had swagger, and appetite, and ambition to burn. He had published his first two books, *Golden States* and *A Home at the End of the World*, when I met him; I was just making my way toward my first, and he read the sweaty apprentice pages of that novel many times. Our friendship spanned many days, many nights, many conversations and confidences, many adventures and misadventures. The fact that he was more famous than I was, then and now, felt in large part like permission: I could run as fast, hit as hard, and demand as much of the world as I wanted without ever being in danger of losing him by going too far, because he had always gone farther. There was nothing I could write, and very little I could do, that would shock or dismay him. For a woman in this world, or at least for this one, that's life giving.

As I began venturing into the literary world as a writer in those years, I sometimes felt I was entering a retrograde realm where divorce was big news, queer people barely existed, and the only people who could write about sex were still Philip Roth and John Updike, whose imaginations in that area didn't seem to extend much past adulterous heterosexual hate-fucking. And nearly everyone, of course, was white. With the millennium just a few years away, queer women were eating fire at demonstrations, becoming mothers, and cocreating ACT UP, but in contemporary literature we were almost nowhere to be seen and rarely, if ever, through our own eyes. Female writers who were widely known to have female partners demurred in public that they "didn't talk about their personal lives." The Sontagian prestige closet seemed to be the going

model for any queer woman writer who wanted to be taken seriously by the establishment. To me, it seemed that the culture at large had progressed far beyond where it was when I was first coming out, but that literary culture was lagging way behind. I had so much I wanted to write about, and the existing space in the literary world at that time for someone like me was so very constricted. It was still a desert there. Finding Michael was like finding an oasis.

If Setterfield felt liberated by Merce Cunningham saying, "Don't make everything so pretty," I felt liberated by Michael saying, in effect, "Don't hold back." So I didn't. For a long time, I thought of him as chosen family, and that family grew over the years; sometime around 2002, various queer circles of which we were each a part also found one another and came together. In one of those miracles of time and place, a scene grew, like a wild garden designed by Darrel Morrison. It was various, decentered, communal. Most of us were queer, though not all of us; we had what I think of as a queer way of being: unconventional, improvisatory, open. We all lived in New York; many of us were in our forties or slightly older, out for decades, deeply committed to our artistic practices, not especially monogamous, and culturally omnivorous. At its height, this garden grew to comprise other writers, artists, actors, musicians, rent boys, dancers, children, shrinks, academics, people who ran things, and people who sang for change in the subway.

This was a time of shaggy gatherings in living rooms, a yearly ritual of staying up all night together on New Year's Eve, for some a fairly substantial intake of drugs, drag everything, and, in some of those living rooms, what seemed to be a lot of afghans covered in dog hair. Radical faeries—those queer neo-pagans who often live in various intentional communities—came through from time to time, trailing their own special magic. Sometimes, an erudite philosopher might turn up on a sofa, sitting next to a faerie named Jupiter. The art-making flowed in its own idiosyncratic way. One of the best performances I've ever seen in my life was an older

faerie with a receding hairline named Agnes dancing with a vacuum cleaner to Al Green's "Love and Happiness" on a makeshift stage (i.e., a really big piece of plywood) upstate.

Varying groups of us spent holidays together, traveled together, went down to the radical faerie sanctuary in Short Mountain, Tennessee, for May Day and other gatherings, took one another in during times of crisis. These were the people I was with after 9/11, during the New York City blackout of 2003, on the grim night when Bush won the 2004 election, and the exuberant night when Obama won the 2008 election. I wrote much of my second novel in a structurally dubious, mold-infested barn upstate on a property collectively owned by two friends who were a couple, a dancer with the New York City Ballet, a shrink, and a legal scholar. For years, we all had regular salons that often included both known performers like John Cameron Mitchell, Basil Twist, and Justin Vivian Bond, as well as people no one has ever heard of who danced in sparkling red shoes and their underwear, sang peculiar and wistful songs, or, on one occasion, showed many, many, many slides about death because it was their seventieth birthday. It was glorious.

I don't know what the formula is for a vibrant scene, but I suspect it is a delicate combination of abundant talent, enough resources (but not too many), erotic energy, geographic proximity, and a shared sense that here, only here, can we be entirely ourselves. When I read about Bloomsbury; or February House, the house near the docks in Brooklyn where Carson McCullers, Jane Bowles, Gypsy Rose Lee, and W. H. Auden lived together in the 1940s; or the early days of the Velvet Underground; or the Harlem Renaissance, I catch the scent of that unique alchemy. No one alone can make it happen; people together can only let it happen and then encourage it to keep happening as long as they can.

We don't have a word in English for this sort of intimacy, but it is a uniquely powerful one. For me, the experience nearest to it is what it feels like when one has been in a club, dancing for hours,

and the group energy seems to become an organism of which one is only a part. During these years, several of us often went to the weekly tea dance Body and Soul, on Beach Street in Lower Manhattan, which began on Sundays promptly at 5:00 p.m. and ended at 11:00 p.m. That was the most mixed crowd I've ever been in; we all came to dance as if our lives depended on it. Something happened at those dances, something on the edges of the sexual, the mystical, and the biochemical. When you went back out on the street, you felt like you knew something profound that couldn't be spoken in words. That's what a powerful scene feels like. "Skin to skin" is a good term for this, as well as all kinds of intimacies that flow through and around categories of romance, friendship, artistic partnership, and collaboration. Up that close, everything—the beautiful, the troubled, the tangled—comes through. I felt skin to skin with the people in that scene.

In that place, I became; writing and publishing my books was only one part of that becoming. I thrived there from about 2002 until 2010 or 2011, during which time I published two more novels. The outer world in which I strived could be a restrictive and punitive place with what seemed to me like a particularly dismal attitude toward female sexuality and female agency. At home with this tribe, however, the right to joy and exploration was a given. (As one of us put it then, "There are no rules, but there are consequences.") For women in particular, this sort of space is rare. People—many of them other women, unfortunately—police women relentlessly, while also making use of them at every opportunity. I felt fortunate to have a community in which I not only didn't have to deal with the standard rules and shamings, but I was also considered to be responsible for the consquences of my own actions. I felt, in other words, like an adult, a 360-degree human being with a heart, a mind, a body, and a soul.

However, in the same way that things come together organically, things come apart organically as well. There arrived a time

of great breaking. Long-term relationships, including mine, shattered; friendships pushed to the breaking point broke; terrible and unexpected illnesses blew lives into bits; people's demons came for them; people suddenly moved far away; disappointments grew too deep. One of us got arrested by Homeland Security. Michael and I came apart. We all got older.

When Hurricane Sandy swept through New York in the fall of 2012, these were still the people I checked in with, but our own hurricane had already swept through and scattered us. It's a truism that rough times either bring people together or tear them asunder, and, despite our sense of ourselves as special creatures inventing new ways to live, we were no different. As one of us put it so well, "We said we were a family"—beat—"and then we were." Sometimes I think that's just what happens with human beings if they hang around together long enough. Sometimes I think we failed one another. I am certainly acutely aware of my own failures. That wild garden no longer exists in the way it once did. I still miss it.

As the years go on, I see how much a particular moment in history may have helped bring it into being. We were the generation that had come out as young adults around the late seventies to early eighties and were coming into our power, economically and culturally, twenty-some years later. When Michael and I met in that classroom in the early nineties, we were both already part of an expansive queer world that was especially dense and active in New York City. We recognized each other as citizens of that place. The AIDS crisis had impacted many of us; some of us had been saved from certain death by the new protease inhibitors and had fought tooth and nail to move the medical establishment and the government. That cab I got into in 1980 had stopped in an entirely new queer land twenty years later, a land of love and death and heroism and invention, with a visible history and future. I knew that I had helped make it, in whatever small way, along with everyone else

there. Massive forces, like tectonic plates, came together to create the energy that coursed through those living rooms and barns and dance floors, an energy certainly affected by our collectively heightened awareness of mortality. Over time, those plates shifted again, as they always do.

While I care greatly for many of my students, I don't offer to them what Michael and the scene where we flourished together for a time offered to me, nor do I expect from them what I gave. I think of this as having boundaries, which is respectable enough, but what may be closer to the truth is that I couldn't stand to have my heart broken like that again. I don't know if I would say that there is no real education without the risk of heartbreak; perhaps that's too extreme. I am, however, quite sure that there is no real art-making without the risk of heartbreak. The skin to skin that can generate art is a state that can last for a second or for years, and that always carries the possibility of the pain of loss.

==

In *The Polymath*, Chip says that "the sexual generosity of the city around me" when he was writing his first books in the early 1960s was what nourished and sustained him. "The sex made the work bearable" is the way he puts it. But since this was the early sixties, queerness was seen as a pathology and a crime. In group therapy while recovering from the nervous breakdown he had around the age of twenty-two that sent him to the hospital, Delany heard himself talking about his gayness as a terrible problem. "I'd used all this borrowed language," he recalls in *The Polymath*. It woke him up. He decided, "I'm not going to use that language again. I'm going to talk about it just the way it actually strikes me." He became, in other words, the author of his own life, to save his life.

Other paths for artists, however, are always possible. In 2007, Delany published perhaps his "straightest" work of fiction, not in

terms of sexuality, but in terms of form. In *Dark Reflections*, Delany limned the life of a gay Black poet named Arnold Hawley. The novel moves backward in time, beginning in 2004 when Hawley is sixty-eight and finishing in 1958, when he is twenty-two. In 2007, Delany was sixty-five, just a few years younger than his protagonist. Hawley, however, is like the photographic negative of Delany: devoted to poetry and poetry alone; repressed, fearful and judgmental of post-Stonewall gay liberation, and all but celibate; at every juncture where his life might have widened, Hawley has chosen to narrow it. Like John Marcher in Henry James's exquisitely heartbreaking novella *The Beast in the Jungle*, Hawley's tragedy is everything he doesn't do, doesn't dare, doesn't allow himself to feel. He is skin to skin with no one. It is a tragedy not of a single dramatic act, but of the same, highly socially acceptable refusal repeated over and over—a tragedy of negative accretion, of the ultimately crushing weight of an unlived life. *Dark Reflections* is a deeply sad and even angry book, a conventionally written novel of a man so conventional that he basically drives himself insane.

As a counterlife, Hawley's feels like a list of everything Delany refused to refuse, as it were: sex, appetite, unrespectability, and what the critic and writer Matthew Cheney has called Delany's "multiplicity of experience . . . of reading, of writing, and of living." Cheney writes that, for Delany, "An experience of multiplicity encourages chance encounters, new knowledge, and better social and political systems."

That "experience of multiplicity" includes, of course, the multiplicity and fluidity of genres at which Delany has been so virtuosic. Hawley, by contrast, is a literary purist. His reward for this self-massacre is eight well-regarded books of poetry, an award or two, and his one shining moment, winning the (fictional) prestigious Alfred Proctor Prize in Poetry—the first Black winner ever. The extent to which Hawley clings to this prize as he grinds away at adjunct teaching and huddles in his rent-stabilized apartment,

vocationally hyperfaithful and terrified of life, is an indictment not so much of the character as of a mainstream literary system that demands what Edmund White, in his blurb of the book, rightly terms a "martyrdom."

Hawley is continually degraded and exploited, but he perseveres, never wavering from a faith in "art" that somehow justifies the deprivation of every human need, pleasure, experience, and vital connection.

He is a dark reflection, indeed, a doppelgänger of a man Delany might have become. Hawley is entirely inoffensive, completely realistic, likable, and terrifying. He has a long run, to be sure, but in order to produce it he has traded away the lion's share of his soul's potential. *Dark Reflections*, which is built of smooth, clear, piercingly astute and sometimes subtly lyrical sentences, is quite a good book. Perhaps Delany needed to be past sixty before he could look full on at this shadow. Or perhaps I'm projecting; perhaps Delany doesn't have any identification with Hawley. When Ghansah asked Delany about Hawley, he replied, "Oh, the differences between me and Arnold Hawley could fill a book! . . . Certainly, when I conceived Arnold's story, I wanted to write about somebody who was as close to my opposite as possible."

When I remark to Delany that he has been bold, he replies, "What you call 'boldness' has a very clear and definite source. One is a piece of advice that came by way of Jean Cocteau: 'What your friends criticize in you, cultivate. It is you.' Several people claimed I was promiscuously autobiographical, and it used to bother them, so I cultivated it. Something that went along with that in terms of being a gay man who was interested in having a lot of sex: where it happened, it happened where people could see, [but] the fact was [that] straight people didn't want to see it or didn't want to know it even when it was going on around them."

Ironically, Delany and Hawley may share another quality, which is hiding in plain sight—even when, in Delany's case, one isn't hiding

at all. In his vast body of work, his densely lived life, he is so very, very *there*, and yet it must be said that in terms of mainstream recognition, Delany yet remains somewhat marginal. A novelist friend of mine used to regularly nominate Delany for a MacArthur Prize, to no avail. None of the major literary prizes has ever gone to Delany. He is, perhaps, too prolifically queer; too polymorphous in all regards, including genre; too hard to classify; and, I suspect, too content. The literary world tends to look askance, still, at full-throated, unpunished desire. And yet there he is, and has been, blazing away, like another sun.

I am not sure, however, that it is the sheer size or force of Delany's desires and talents that has sustained him for so long. In *The Polymath*, he says, "My perception of myself is that there's not a lot of me. There's just a big emptiness in which there are a whole lot of words swimming around all the time." Later, he continues, "I think of myself as I walk through life as the world's most ordinary, dull, boring, Black faggot." He tells me that, at seventy-eight years old, "I don't even think about undertaking major projects anymore. Mostly what I think about now is very much in the line of sweeping up, and as I say [in *Solids and Surds*], 'getting ready not to be.'" He is as frank about getting old as he has been about everything else in his life. However, *empty* and *dull* are two words I wouldn't use to describe him and it is difficult to imagine a personality so large not being.

If one regards Hawley's story as a cautionary tale, the moral of *Dark Reflections* might be summed up as: allow yourself to be touched, even to be shoved, to be moved, to be pulled and pushed by the world or risk an ultimately deadly self-enclosure, lost in space with just a bit of shriveled self for company. As Cheney points out, for Delany, the chance encounter is the wellspring of rich possibility; to wall oneself against it is to entomb oneself. When I ask Delany what has sustained and driven him over the long run, he replies, "I've always liked Harold Bloom's general answer to the question, and

also Theodore Sturgeon's comment. . . . Bloom first: artists in general create from the fear of not recreating, which fear they equate with death. Sturgeon second (he's my nominee for the most underrated American short-story writer of any genre in the second half of the twentieth century): I write because of all the things I can't do in the living room."

Perhaps, for this Harlem undertaker's son, a member of the Black elite, grandson of an enslaved man, that fear of not recreating, a fear unto death, would come true if one confined oneself to the living room, like Hawley. Life comes from deep congress with the street, both literally and figuratively.

Delany is, certainly, a rare and incandescent talent, but somehow it looks to me as if his prodigious energy has been both a quality he has brought into the world and one that he has invited, even entreated, the world to bring into him. His is a kinetic constitution, like a flywheel. His ars poetica may have been radical permeability, and not only sexually. He recalls to me of Iva's infancy, "I used to carry Iva pretty much everywhere—readings at NYU, the supermarket on Columbus Avenue, to this or that midtown office—in a papoose-like arrangement. When your kid's on your back and your mind is somewhere else, and her hands touch the back of your shoulder or your arm, it's an astonishing feeling." Then he muses, "I don't think I've ever put it in a novel."

———

When I was twenty, I went to a dusty Upper West Side movie theater that no longer exists to see *Taxi zum Klo*, directed by Frank Ripploh. It was the afternoon, and hardly anyone else was there. In the film, a gay Berlin school teacher has lots and lots and lots of sex with different men. In the scene I remember best, he leaves a hospital bed to stand in a park in the snow, still in his hospital gown with his hospital bracelet on, cruising. In my memory—I

haven't been able to see the film anywhere since—the scene is played not for laughs, but with a wry sort of awareness of both the man's ridiculousness and the gravity of his desire. Sitting in the half-empty theater, I thought, *I could be like that.* About love and sex, but also about writing. Always another try, another shout in the dark, another sentence tethering me from a great fall. When I finally finished my first book almost twenty years later, I thought, *Now I can't be erased. Now I am here. Now the axe has broken the ice.* But there is always a substrate of that ominous silence, and another book to write, another way to say it, to say something, anything.

==

Delany tells me, "For all the forty-odd books I've published . . . I've had between two and ten ideas lasting for ten minutes to ten years on other projects I would like to do. A *very* few of them have been completed. I think of myself as somebody who has *not* written far more books than I have." Even now, that seems a paradise to me, that way of seeing presence everywhere, a never-ending invisible library of potential works.

What I want from Delany, I finally realize, is the secret to that way of seeing, but my request is impossible, because, to him, it's all right there, as real as the sun and the moon and the stars, going on all around us and within us all the time. He's described it so many times, in myriad forms, and in such detail. It's right there. Just go. Dive into the sea of words swimming within. Even if he could tell me the secret, I doubt I would be able to share in it, because that would never be how the world looks to me. The difference between who I was in the years with J and who I am now is that I know that. I can see Delany, but I can't see the way he sees.

Still, for so many of those days and nights when he floated, half-visible, on the edge of my consciousness as a story conjured by a

lover, I was as happy as I imagined this man whom I had never met was. I needed to believe that he was part of a better world, that that world existed, and that I would be welcome there. I needed to believe J on this and many other matters, so I did, with all my heart, even after I left her.

I'll Be Your Mirror

In 2016, I went to an exhibit at the New Museum in New York where I saw a series of sixty photographs running along the length of a wall that had been curated by photography collector Tong Bingxue. In every image, a Chinese man was posed against a studio backdrop. There was a young man in Western clothes and a hat in a photo dated 1909. There was a slightly older man in a long robe holding a cane and a white hat in a photo dated 1924. There was a portly man in glasses in a photo dated 1932. In a 1950 photo, a man smiled in a Lenin cap. In a 1953 photo, a man with glasses was wearing what looked to me like white scrubs, with pens in the breast pocket. And so on until the series ended in 1968. They were all photos of the same man, a lifelong resident of Fuzhou, who had a picture of himself taken professionally every year from 1907, when he was twenty-seven, until the year he died.

The man's name was Ye Jinglu. As the owner of a teashop and a pawnshop who rarely left Fuzhou, he seems to have been entirely unremarkable, except for his practice of the annual studio portrait of himself alone, maintained without fail for sixty years. We see him change physically—hair, body shape, an eyelid that begins to droop, and as the series goes on, he smiles, which he doesn't do in the early photographs. In the most ordinary way, he also adapts to the times in how he presents himself in these formal portraits.

The shifts in his look—the glasses go on and off, the clothes shift subtly, the fake backdrops change—also become indices of far larger changes in his country. He was having a picture made of himself, but, as Tong explains in his book about the archive, *A Life in Portraits*, he was also creating a time-lapse series of nearly a century in China, from the end of the Qing dynasty through the time of Sun Yat-Sen and then Mao.

In an interview from 2012, Tong says that he imagines Ye's annual ritual like this: "He would dress up in new clothes, put on his new shoes and hat, walk slowly down a long lane and finally enter a photo studio," where he would carefully curate and prop that year's image. Perhaps the most remarkable thing about this man isn't that he had his photo taken, but that he never missed a year. The camera is a record of Ye's tenacity, but it doesn't tell us why this ritual was so important to him. There is a remainder we can't see. He demonstrates history, but the very persistence of his practice suggests that there is something in him history doesn't touch, something that remains quite private.

=

The actress Blair Brown, born Bonnie Blair Brown in 1947, grew up outside Washington, DC. She was an only child; her father was an analyst for the CIA and her mother was a teacher. Because of her father's job and her mother's southern upbringing, Blair says, "I grew up in a house of secrets. . . . I was used to pretending and lies." As a child, Brown was told she should say her father worked for the State Department. When she got older, she was told she should say her father sold greenhouses. After high school, Brown eventually decided to go to drama school. She graduated from the National Theatre School of Canada in 1969. For her audition, she tells me, she had to do one up-tempo piece and one classical piece. She chose material from *Medea* and *Long*

Day's Journey into Night. "I'm not sure," she says wryly, "which one was the up-tempo one."

Brown is seventy-five when we talk, clear-eyed and direct, as charismatic in person as she is when she's performing. She Zooms with me from her house outside the city. In the background, I can see a big, rangy white dog walking around, a highboy, a wall of books. In the foreground, Brown, white-haired, wears her glasses on top of her head and a striped button-down shirt. I keep thinking I hear just the slightest trace of a southern accent, but then it disappears into a precise elocution. What comes across most distinctly on first impression is her intelligence, or perhaps a more exact word would be her *awareness.* Even when she's the one talking, she seems to be listening. I always have the sense of a keen perceptiveness on the other side of the screen. What I mean is: I always wanted to know what she was thinking. It's a quality the best actors have, that ability to convey the presence of a dense inner world even while seeming to do nothing out of the ordinary.

Brown has been well known since she was in her twenties, when she won major roles in films such as *One Trick Pony, Altered States,* and *Continental Divide.* From 1987 to 1991, she was the lead in the television series *The Days and Nights of Molly Dodd,* a half-hour weekly dramedy in which Molly, a divorced woman in her thirties, navigated life and love in New York City. She appeared on Broadway many times, notably in the Michael Frayn play *Copenhagen* in 2000, as Margrethe Bohr, the wife of physicist Niels Bohr. The playwright David Hare, with whom she was involved from 1985 to 1990, wrote the film *Strapless* and the play *Secret Rapture* as vehicles for her. Television has also been a mainstay for her. She was the formidable Nina Sharp on the sci-fi series *Fringe* from 2008 to 2013. From 2015 to 2019, she was inmate Judy King, a sort of mash-up of disgraced pop culture domesticity queens Martha Stewart and Paula Deen, on *Orange Is the New Black.* These are just some of the highlights. The shutter has clicked,

the camera has rolled, and the curtain has risen many, many times over the course of Brown's career. When I interview her, she had recently appeared in a major role on Broadway in the Tracy Letts play *The Minutes*, which concerned the unearthing of racial trauma in a small town.

I look at Brown on screens and YouTube portals and through the lenses of myriad directors; I scroll through articles and interviews from the 1980s to the present day. I go to the New York Public Library for the Performing Arts, put on headphones, and watch a recorded performance of *Copenhagen* from 2000. On *Fringe*, I wonder how they made Nina Sharp's terrifying black robotic arm, a character in its own right and a contraption that seems to signal both Sharp's power and her possible ruthlessness. Watching Brown's performances from 1980, when she was thirty-three, up to 2019, when she was seventy-two, gives me the stereoscopic sense of both an artist's oeuvre and the culture's various ideas about what a woman like her might be in this world. Running alongside this is what Brown tells me about her life. Taken together, they're a fascinating, forty-years-long-and-counting essay on art, life, and culture, particularly for women.

One of my reasons initially for wanting to talk to Brown is that I wanted to hear from someone who had a rich, decades-long experience of mainstream fame and was both willing and able to delve into it for this book. As I spent time with her and her work, however, I remembered that fame is perhaps best understood as a funhouse mirror reflection of ourselves—our fantasies, our contradictory impulses. The talent belongs to the player, but the size and character of the projections often belong to us.

———

The visual artist Roni Horn put together a series of thirty portraits in 2008–2009 called *a.k.a.* I saw it as a spread in *W* magazine; it was

also exhibited in the Museum Folkwang in Essen, Germany, and in other galleries. The series comprises thirty photographs of Horn from infancy to young adulthood to her fifties. These pictures are electrically discontinuous. In some, Horn is a long-haired hippie girl; in some, a little girl in a high-necked dress; in some, a soulful soft butch; in one long shot, peeping above a rock in Iceland with a great mass of Pre-Raphaelite hair, a fantastical being; in some, in the excellent phrase of performance artist Peggy Shaw, a "menopausal gentleman." If one didn't know that they were all Horn, they might seem to be entirely separate people. Juxtaposed, the images ask, What/where/how is the self?—a long poem of inherent mutability. The series of images is also a Rorschach test for the viewer: Who is the hippie girl to you? The fantastical being? The menopausal gentleman? What characters do they play in the theater of your mind?

=

The line from Rilke that Samuel R. Delany quoted—"Fame is the sum of all the misinformation current about you"—applies not only to Brown as a person but also to her roles, composed as they are of various mainstream cultural constructions of women, spun of wishes, inhibitions, and projections. She once played Jackie Kennedy to Martin Sheen's JFK in the 1983 miniseries *Kennedy*—a famous woman playing an even more famous woman who often seemed herself to be playing a role, exquisitely attuned to what the world wanted to see and faultless in delivering it.

Fame, of course, is also famous for waxing and waning. When I ask Brown what it was like during times when she was more famous, she says, "I will say that I thought it made the world very pleasant. . . . You would walk into a restaurant and people would say, 'Oh, hi!'" She tells me that one time when she was shooting a scene in a very expensive shoe store in SoHo for *The Days and*

Nights of Molly Dodd, she saw two beautiful pairs of shoes she wanted. When she went to pay, her money was waved away. "What I remember thinking was, in ten years, that's when I'm going to need some free high heels." She also says, "I mean, I had my share of stalkers, like everyone does." The guy who found out where she lived and came to her front door; the unhinged woman whose behavior caused Brown to have her friends take her young son upstate for a while. She doesn't seem especially fazed by having had stalkers; stalkers often feature in the lives of the famous. They feature as well in many women's lives.

About finding oneself less famous, Brown says, "At first, it's really disappointing. You think you've done something wrong. And then it comes back for little bursts . . . but by the time it comes around again, you go, 'Yeah, yeah, I know what that is.'" She laughs. "I definitely should have gotten more shoes." Brown says that what fame does is "open you up to more work opportunities, but not always ones that are particularly good for you. You just get sort of offered everything." She quotes lines from David Hare's play *Plenty* in which a character talks about the way the stock of professional standing always rises and falls. It's folly to believe that one's stock will never fall. "You might have a friend, say, who [is] being very kind to you, [but also] slightly patronizing, 'cause they think, 'I'm famous and I always will be.' But then you come back six years later, and . . ." She shakes her head. With the streaming services, she says, these cycles of fame are even faster. "It's not even sort of there," she says, before it vanishes again.

In Brown's films from the 1980s, she often seems to be a latter-day Katharine Hepburn, updated for a time when women could swear in public and be known to have sex. She strides; she has great cheekbones; cameras linger on her spill of auburn hair. She has an upper-class vibe and her diction is crisp. Hollywood seemed to have decided that she could embody the image of the self-possessed, well-educated white woman of the time, believable as a renowned

eagle researcher living alone on a mountain (*Continental Divide*) and as a brilliant anthropologist (*Altered States*) while also generating considerable sexual heat with costars such as Paul Simon, John Belushi, and William Hurt. In several films, she is cast as the ex-wife of the male character at the center of the movie, alternately nagging and consoling the variously tormented bad boys whose existential crises are, of course, the heart of the drama.

In *One-Trick Pony*, a film that is entirely concerned with singer Jonah Levin's heroic struggles to maintain his artistic integrity in a music world of knaves and fools (Jonah is played by Paul Simon playing many Paul Simon songs), she is his ex-wife, Marion, who is given the thankless role of calling rock and roll "pathetic" and exhorting Jonah to grow up already while also still being insanely attracted to him, as all the women in the movie are (inevitably, they bare their breasts, which seems to be a requirement for being in the movie if you're a woman). When Jonah comes over, she is frequently already (un)dressed only in a silky robe, which makes having sex much quicker and easier. That seems to have been her job, since there was no evidence of her doing anything else to support herself and the son she has with Jonah. After two days on the set, Brown tells me, she tried, unsuccessfully, to get out of doing the movie at all, because Simon and the director of photography were so controlling. Since she couldn't get out of it, she just got through it.

In *Altered States*, she is physical anthropologist Emily Jessup, ex-wife of William Hurt's Edward Jessup, a psychopathologist who gets way too into mixing long sessions in flotation tanks with taking hallucinogenic substances and goes back to the beginning of time, sort of, while also sometimes becoming a Neanderthal with gorilla feet. In this film by Ken Russell, it's complicated, visually and otherwise. The short version is that Edward begins sailing out to the edge of being; Emily's job is to pull him back to earth. Although she and Edward are divorced, she's still "possessed by him," as she puts it. She says things to insatiable seeker Edward, like, on the

subject of his lovemaking technique, "I feel like I'm being harpooned by some raging monk in the act of receiving God!" When he asks, "Shall I try to change?" she says, "No, I kind of like it." At the end of the movie, not long after he's reverted to a primordial form of humanity and eaten an unfortunate live goat in the zoo, she also rescues him from a vortex of all consciousness (I think— it's a huge swirly whirlpool thing that floods the lab and possibly threatens civilization), using considerable strength to wrestle him out of the Beyond and then cradle him to her chest. Rescued by her love and fully human once more, Hurt opines, "The final truth of all things is that there is no final truth." As they entwine nakedly, he says, "I love you, Emily," and the movie ends.

Even in romantic comedies, Brown is called upon to be both desirable and tough. In *Continental Divide*, the Tracy to her Hepburn is John Belushi (really), playing a rumpled Chicago newspaper reporter who tracks down an eagle researcher on her lonely mountaintop for a story. When Brown, as the eagle researcher, isn't splitting wood, beating hunters with their own guns, and showering delectably with her back to the camera, she's tending Belushi's wounds. When he gets attacked by a mountain lion, she bandages him tenderly before making love to him. When he falls down a snow-covered mountain, she quickly fashions a stretcher-sled out of rope and ice, rappels with him down a cliff face, and pulls him miles back to her isolated cabin so she can heal him. At the end, he marries her. Who wouldn't?

What's amazing about Brown in these roles is that she not only sells them, she also makes being that kind of woman look effortless. Vitality, strength, sexuality, and intelligence shine out of her. It's no easy task. It's shocking to watch these films now—how did I manage to forget how it was?—and see all the straight white men in a clump in the center of the stage making the decisions, running the world, and having the Important Feelings. Brown had top billing as costar in these movies, but the movies weren't all that

interested in her characters, who were there to act as foil or ministering angel to the men, while also looking great naked. In these movies, the men are falling apart for one reason or another; since Brown's characters exist to put them back together, we in the audience have to believe that she can do it, and we do. One can't really draw broad conclusions from a handful of films, but from here it looks a bit as if, having recently been made aware via second-wave feminism that women were strong and smart, some men thought, "Great, now they can help me!" Brown was frequently tapped to play those women.

Even as late as 2000, in Frayn's play *Copenhagen*, Brown was cast as Margrethe Bohr to Philip Bosco's Niels Bohr and Michael Cumpsty's Werner Heisenberg. The play centers on what may or may not have happened during a meeting that did actually happen between Niels Bohr and Heisenberg in Copenhagen in 1941, and what that may or may not have had to do with the invention of the nuclear bomb and the outcome of World War II. Formally adventurous and intellectually nimble, the play is essentially a series of conversations among the three characters, after their deaths, on a bare stage with three chairs. While Niels and Werner discuss quantum physics and the fate of the free world and what their respective roles in the latter may have been, Margrethe narrates their meetings and their feelings or listens attentively, legs crossed at the ankles, in a knee-length skirt and sensible shoes. She does come forward at certain points to speak from the moral center of the play, calling Heisenberg out for arrogance and egotism, and she reveals depths in the marriage that her husband avoids. Still, it's difficult to know what to make of the line oft repeated by the two men, concerning how to present science to the public: "In the end, remember, we have to be able to explain it to Margrethe." Brown won a Tony for that role, which she deserved not least for suggesting by her astute presence that the line might just possibly have been meant to reveal the biases of the two male characters.

As an actress, Brown never seems to be entirely consumed, or subsumed, by whoever is holding the camera or writing the lines. No matter the material through which we are looking at her—and, often, that material has had almost supernaturally sexist limitations—one always feels that there's a tremendously alive person in there, looking back. When you see her playing one role, you're aware that this person could do many things, in many places, and in many ways. Because something in her always seems to exceed or escape the role, one is more than usually aware of what those roles reflect about the culture at large—us, in other words—at any given moment.

Brown has been outspoken about wrestling with the sexism in her industry. In an interview with the *Wall Street Journal* in 2016, she said, "I hated being 'the girl.' As in, 'The girl can stand here and John will stand here,' because the actor would be named, of course. I was happy to work, but I didn't like being trivialized." In the years when she was often going out to California for roles on television shows, she took a Valium every morning to "be able to deal with it without punching someone in the face." She tells me that when she was working for NBC, "whatever show we were doing, they wanted me to have larger breasts. . . . Even Westerns. I used to have a padded bra . . . hanging up that I called my 'NBC tits.'" When I ask her how she continued to persevere under these conditions, she says simply, "My life wasn't like that. The men in my life weren't like that. My representation—my manager, my agent—weren't like that."

In life, Brown was partnered with the actor Richard Jordan, with whom she had a son in 1983. They lived in what were then the wilds of Chelsea in New York, in an apartment for which Brown's role as Jackie Kennedy provided the down payment. Nearby Tenth Avenue in those days was, Brown recalls, a sketchy terrain of prostitutes and guys from New Jersey driving around trying to pick them up. One of her neighbors was the writer Laurie Colwin. Often,

Brown, Colwin, and others would make a pitcher of margaritas, sit on the stoop, and watch their kids learning to ride their bikes. Brown had no desire to marry Jordan—"Why would I invite religion or the government into the most intimate relationship of my life? I never got the point"—nor David Hare, with whom she was involved after she and Jordan split up, nor Dwight Lee, the businessman who is her current partner. (Jordan died of brain cancer in 1993.)

If you look up Brown online, you might see her referred to as David Hare's "muse," a term that was also used about her in the *New York Times* in 1989 when she starred in his play *The Secret Rapture*. Valda Setterfield was also often referred to as David Gordon's "muse"; Arlene Croce wrote that he became a choreographer once he met her, "as if he had been given a beautiful live doll to play with." The gender math here isn't hard to do: there is a male maker and a female enactor of his vision, an instrument on which he plays. He is the artist. She is the material. If the two are also linked romantically, the sexist grid is only reinforced.

Asked about being a "muse" in 2012, when she was seventy-eight, Setterfield said, "In the beginning, I thought my mission in life was to serve the artist." However, during the AIDS epidemic she began attending meetings at Friends Indeed, an organization that supported both people living with HIV and the caregivers in their lives. There, she said, she learned that "one's job in life was to take care of oneself so that you could offer everything that you could as fully as possible because you were whole in yourself. That was very shocking to me. I began to be more of a nuisance." She continued, "The big change in whatever a muse is, is that I speak out a lot more."

When I ask Brown about being called Hare's "muse," she says, "Well, we talked every day on the phone. . . . We talked about everything. In fact, we talked so much that MCI—remember them?—thought I was a business and offered me a corporate rate." I ask

again if she thought of herself as his muse, and she replies, "No, we were just like great friends."

It's the old story: conversations and collaborations among male and female artists in which influence flowed around and between them are recast as hierarchical transactions in which he made masterful (pun intended) use of her as a resource to be extracted and shaped.

However the culture might have framed her, Brown just got on with her work. In the years when she was doing *Molly Dodd*, her son's school kept asking her to help set up the apple festival, the book fair, and so on, as the mothers, of course, were expected to do. Again and again, Brown said she couldn't. "This woman at the school," says Brown, "was getting grumpier and grumpier. [Finally,] I said, 'Okay, here's the deal. On Monday mornings I get picked up at 5:30, I get home at 7:30, and that's my shortest day.' She said, 'Oh, you work like my husband.' I said, 'Yes. I work like your husband.' . . . They stopped calling me after that."

Molly Dodd was a breakthrough role for Brown, but Molly Dodd was also a breakthrough for the culture. Single, complicated, resilient, and urban, Molly is part of a female television lineage that includes Mary Tyler Moore tossing her hat up in the air in Minneapolis, Marlo Thomas's *That Girl*, and Diahann Carroll's *Julia* (the very rare television show at that time starring a woman of color). On these shows from the sixties and seventies, husbands hover only as ghosts: Mary Richards moved to Minneapolis after a broken engagement; Ann Marie (Thomas) had a boyfriend, but didn't marry him until the very last season; Julia was a widow. They were, in other words, marriageable even if they weren't married, and thus semivalidated, these female characters could work, date, feel, and think in the modern world and, most important, be the center of the story—week after week, year after year, straight into millions of living rooms. When Molly, divorced, joined their company in 1987, the show didn't have to draw a veil over the subject

of her sex life, but, perhaps equally radically, she didn't have to have a respectable, driving reason to be single and free in a big city. She wasn't a dedicated newswoman, an ambitious aspiring actress, or a nurse and single mother supporting her son. Unlike the leads on *Cagney & Lacey*, which premiered in 1982, she wasn't involved in the life-and-death stakes of being a cop, either. She was just a person, making it up as she went along.

The show, which is now only available in scattered, badly recorded episodes on YouTube, also refracts Molly through an organic, emotionally complex form of storytelling that didn't conform to any of the prescribed television forms of the time: sitcom, cop franchise, hospital franchise, action-adventure, and so on. Molly has various jobs, various boyfriends, and various spontaneous encounters in New York that add up not to a plot, predictable laughs, or a moral, but to a messy life. The show is playful, tender toward human foibles, and Molly isn't required to rescue anyone or save the planet to justify her narrative existence. She's worth the screen time just as she is. Nor is she a flashpoint or a role model. Several years before the character Murphy Brown caused an actual national crisis by having a baby out of wedlock (Vice President Dan Quayle made her the right-wing dog whistle of 1992), Molly conceived a child with her Black detective boyfriend—one of a few men in her life at the time—to the consternation of pretty much no one. Watching the blurry episodes of *The Days and Nights of Molly Dodd* is like gathering fragments of cuneiform tablets depicting scenes from the life of a happy, free woman from the last century.

What got the show canceled by NBC after only a year, however, wasn't its sexual politics but its form. Brown says that then-president of NBC, Brandon Tartikoff, "just did not understand the show and did not like it. It really annoyed him." Added to his annoyance with the show's unpredictable blend of comedy and drama was a desire to "sort of fix Molly, basically. They wanted her to have a career and a stable life and a five-year plan. And that was never

going to be this person." Lifetime picked up the show, where it ran for three more years, until 1991.

In *Alice's Adventures in Wonderland*, the imperious Caterpillar peers at Alice and asks, "Who are *you*?" to which Alice replies, "I—I hardly know, sir, just at present—at least I know who I *was* when I got up this morning, but I think I must have been changed several times since then." The Caterpillar is not at all satisfied with this answer and continues to demand that Alice explain herself, which she can't do. Nor does she stop changing. Like the Caterpillar, industries that invest heavily in wide-release narrative often make equally heavy instrumental demands of the characters. In some moments, heroes must be straight white men who save the day; heroines must be straight white women who are either mothers and wives or hopelessly ruined sluts; at other moments, everyone has to be either a player or a dupe in the heist; or everyone has to have rock-hard abs; or all the women have to be traumatized; or no one can be on-screen who isn't a very particular cog in the super-efficient engine of the plot. Romantic comedies must end with happily ever after. And so on.

Like Alice's shape-shifting, the continual shifts in Brown's career defy the Caterpillars of culture. As she puts it when we're discussing the peculiar business of engaging so deeply in intense imaginative worlds and then inevitably leaving them, "You go here, *plonk*. You go there, *plonk*. . . . And you deep dive. [I'm so] lucky. It's worth putting up with the nonsense." In the early 2000s, for instance, Brown sought out the director Chen Shi-Zheng, whose work she had seen at Lincoln Center and greatly admired. "I found him in Los Angeles, . . . and I said, 'I just want to work for you. You don't have to pay me.'" She worked with him for two years, ultimately appearing with Fiona Shaw, Mia Maestro, and others in the musical *My Life as a Fairy Tale*, about the life and work of Hans Christian Andersen, with music by Stephin Merritt. "Fiona was Hans Christian Andersen, with duck feet, I was his mother, with

frog hands, and I wriggled through a tube, singing a fado song writ-
ten by Stephin Merritt. What could be better? It started off with
[us in] these giant eggs up in the air, and then they came down
and we cut our way out with giant scissors. It was lunacy. It was so
great." She still looks delighted. The rangy white dog wags his tail
in the background.

A vibrant long run might be sustained not by armoring oneself
inside an even bigger and more expensive fixed narrative, but by
morphing through a varied series of them over many years. Against
the monument, the mobile. Against the hammer, the leap. You can
be Tom Cruise, playing the same well-oiled hero saving the day over
and over, or you can be Cate Blanchett, playing anyone. Brown's ex-
planation for the range of her choices is practical. "I always figured
you tried to take the best work you could find, and it isn't always
right. . . . Some famous actor—I can't remember who it was—said,
'There are two [kinds of] actors: There are the ones that take the
best job that's available, and there are others who wait for the very,
very best job with the very, very best people. In the end, the amount
of good work is probably about the same."

In his preface to the diary of veteran actor Sir Alec Guinness,
My Name Escapes Me, John le Carré remarks that "some actors, of-
fered work, first count their lines to calculate the importance of
the part," but not Guinness. Brown's mindset is the same. "[When
I was] doing *Copenhagen,*" she tells me, "Michael and Phil and I . . .
were talking to a group of people [after the show one night]. They
said, 'What makes you choose a play?' [Michael and Phil] were talk-
ing about choosing a part that mattered, and I said, 'Well, I choose
the play, 'cause if I chose the part, I wouldn't be in this play. I'm not
playing a part, I'm playing a device.' . . . But I was so admiring of
that play, and I loved standing on the stage eight times a week say-
ing those words."

Like Delany, Brown has been prolific, kinetic, willing to tra-
verse genres from sci-fi to high lit and mediums from the stage to

the small screen to film. Over time, as practical as it may be, this approach also constitutes an ethics of art-making: bulletproof or fundamentally porous? In building conservation, a debate has emerged between those who want to scrape and clean and blast an important building back to a pristine state and those who argue that the patina and even decay over time are intrinsic to the building's being. Moreover, say the latter, like Darrel Morrison's distinction between "frozen" and "fuzzy" landscapes, the continual removal of history only creates an entirely artificial structure, a hyperclean edifice that basically never was, cryogenically stilled.

In a 2003 essay titled "The Panorama Mesdag," the poet Mark Doty draws a contrast between the august Mauritshuis Museum in The Hague, with its framed Rembrandts and Vermeers, and the low-art, even kitschy, nearby *Panorama Mesdag*, an unframed circular seascape painting of a beach in 1881 that entirely surrounds the viewer. You are meant to walk into the *Panorama Mesdag* and be hurled back in time. It is not a good painting, Doty explains, but it does something else that is revelatory. "Weirdly, you realize instead you are *inside* of something. The 'world' around you is a work of art, and you are its center. That center is strangely, unnervingly unstable, because every way you step your perspective changes a little."

Doty finds the panorama fascinating in its slightly cockeyed attempt to immerse us in a particular moment, a painstakingly detailed wish that ironically results in an awareness of our own historical contingency. "Oddly paradoxical, and oddly moving—to be reminded that we stand at the center of our own lives, and that those lives are historical, and fleeting. What could the effect be, then, but tenderness?"

Indeed, Doty remarks that, for him, the *Panorama Mesdag* would have been elevated from gimmick to, perhaps, art if it had been allowed to mildew, to let the mice get at it. He would have welcomed the evidence of "time's delicate ruination of human ambition."

Time, as we know, has often been especially terrorizing for ac-

tresses. Much ink has been spilled about the extreme efforts to conserve the faces and bodies of women whose art is performance. These discussions frequently revolve around the constraints of what women are or are not allowed to "be" at a given moment, unrealistic standards of beauty, and who is represented—that is, who counts—in the vast funhouse mirror of culture. All true. However, that demand for physical fixity also carries the freight of an impossible wish that some people in this world stand outside of history, that beauty offers an unearthly and untouchable power that is permanent. Equally as compelling may be the fantasy that we in the audience can return to that beauty and find it unchanged. We can go home again for as long as we want, to a face that is just as we remember it. That beautiful one will always stand ready to fashion sled-stretchers and pull us over the snow or drag us back from being lost forever in the whirling vortex of the universe. As with many cultural wishes that women are exhorted to fulfill, it can't be done, only rigged up to look like it.

Patti Smith, writing about Jeanne Moreau's performance in the 1966 film *Mademoiselle* for *High Times* in 1977, raved that the actress was like "a barbed wire fence on fire." Moreau's previously prim schoolteacher character has a passionate affair with an Italian lumberjack, and Smith writes that after two days of rolling around in the fields with him, "she's like a lioness and she comes in[to town] with her chiffon dress all blood and filth and she's like real satisfied and they see her and the women all get hysterical. She's like the symbol of purity, their Madonna, Marianne Faithful, and they can't believe she's been so defiled." The townspeople kill the lumberjack, killing the messenger who has brought the news that no one is made of alabaster.

Smith loves this quality in Moreau, but the mainstream American entertainment industry tends to prefer the alabaster, particularly when it comes to women. It's an awful wish, and it's had awful effects on the human beings who turn their faces and bodies to stone

in an attempt to fulfill it, but there is also something desperate and sad about that wish. Why are we, as a collective audience, so frantic to be endlessly reassured, turned on, and protected by petrified beauty?

Brown recalls that, for one television show about the Oregon Trail that she did early in her career, her character was supposed to have a fight with her husband. She threw herself into the scene, upon which the director took her aside and said, "Now, you know this is going into people's homes, right?" She laughs. "I wish I'd had the presence of mind to say, 'Their fights are far worse than that.' But I love that he was just trying to help me out—like, 'You don't want to be that ugly. . . . Be girl mad.'" Later, she was cast as a lawyer in a 1978 mini-series called *Wheels*, with Rock Hudson. Opening *TV Guide*, she was surprised to see that in an ad for the series, she was wearing a camisole and tap pants and her head had been put on someone else's body. "Never in the entire show do I wear a camisole and tap pants," she says. "Not ever."

"Not to court?" I ask.

"Not to court. Not even under my clothes."

Needless to say, no one had sought her permission for this Frankensteined image.

Given these stultifying conditions, one has to wonder what it is in Brown that has made her able to continue to build a career in performance all her life. That she, or anyone, might want to do it or even be good at it is understandable. But having the stamina for it over decades is more mysterious. Brown says, "A friend of mine, the artist Matthew Weinstein, was teaching . . . and the students were [saying that] if you didn't have a solo show by the time you were thirty, you might as well just get out. And he said, 'So [some of] you could get out? Because if you could get out, you should get out now. . . . This is a profession for somebody who has no choice.'"

That sense of having no choice is the one thing that truly cannot be taught. Talent can't be taught, either, but it can be nurtured

or suppressed. The nearly unbearable sense that your life somehow depends on making art isn't something anyone else can inculcate in you. It's a quality you must recognize in yourself, if you have it, and then decide if you want, or can bear, to heed it. Students and others who are interested in writing often talk about their failures of "discipline" or "commitment," but my own experience is more Moreau than Grace Kelly. I couldn't leave it for Monaco. I feel that I have to do this, and far more of my energy has gone to fighting tooth and nail to do it than has ever gone to maintaining a regime of "discipline." Like Brown, I have sometimes had to discipline myself only to keep from punching someone in the face who has made pursuing my vocation difficult for me. It is not rational. It is primal, the realm of blood and filth. The townspeople frequently get upset.

What Smith seems to be admiring in Moreau's character in *Mademoiselle* is not only her passion but also her shamelessness. The schoolteacher goes back to town in her wrecked dress and she doesn't care who sees her. When I talk to Brown on Zoom, it seems clear that she hasn't blasted her face into an empty alabaster plane. Setterfield didn't care if I saw her without some of her teeth. Particularly for performers, these aspects of self-presentation are choices. It takes one kind of shamelessness to show up on camera naked when you're thirty-three. It takes an entirely different strain of shamelessness to show up on camera with your natural face in your seventies. This second kind of shamelessness is only visible over many years of images accruing. The decision becomes visible very slowly, as does another quality of these two performers, the dancer and the actress: having no choice but to keep doing this.

Given the fact that an artistic vocation can feel like something one is absolutely compelled to do, resisting cultural demands about one's physicality is an especially perilous high-wire act for performers. The Caterpillar might not cast you. The Caterpillar that is the audience might not want to pay to watch you. What's a little flesh snipped away compared to not being able to work? These women, however,

like Moreau's Mademoiselle, walk through town as they are anyway. After all, everyone's chiffon dress gets wrecked in the long run. You can be Smith, seeing that as heroic in yourself and others, or you can be the townspeople, and beat that knowledge to death.

=====

Not all the messengers from within are welcome. In my midforties, desire for men came back into my life, first somewhat haltingly, and then too powerfully to ignore, although I tried. (Around 2008, I said to my therapist, "Here are two words I don't want to hear from you: *menopause* and *bisexual*.") I felt far more shame about this than I ever had about calling myself a lesbian, and, for the first time in my life, for several years, I was basically closeted. I looked one way to the world—a world, personally and professionally, that I had built—but I felt another way inside, and that it would be disastrous to say what I was really feeling to any but a trusted few. I hoped it was a phase, or maybe some sort of treatable medical condition. I felt as much desire for women as I ever had, but now another room had opened within me and it wasn't going away. The identity on which I had built my life, and that had saved my life, was no longer what I thought it was. If this later version of myself were a photograph, it would be a woman I didn't recognize.

Coming out as a lesbian, while it certainly entailed external battles, always felt like fighting for freedom, mine and that of others as well. This, however, felt like betrayal. I was fearful of the breach my shift in identity might cause. Most of the people who surrounded me went for one gender, full stop. The ethics were libertine, but the people weren't particularly sexually fluid. However, if part of the ideology of queerness was following your desire wherever it led, and that desire itself is anarchic and unpredictable, to plump for the comfort of a certain cozy group identity at this late date seemed not only hypocritical but also life-denying. A gay male

friend at the time said, "Why don't you just say you're a lesbian who sleeps with men?," which I suppose might have been possible if I had had zero feelings toward the men I slept with, but that would have been another kind of lie, a more sophisticated closet. It also would have been easier if I had some romance with heterosexuality itself, if I longed for "normality." I didn't. For me, all the romance lay in the heroism of queerness and the inventiveness of queer life. And what would it do to my work?

Finding myself, to quote Amber Hollibaugh again, living a sexuality I didn't understand, I kept trying to frame it in terms I did understand: adventure, erotic byway, hookup. They didn't work. My inner townspeople were threatening to riot, but once again, and with no small amount of reluctance and trepidation, I followed my desire path.

I do still call myself queer, but, as with a refrain, the meaning of that word to me has changed over time. Sometimes, I actually like the word *bisexual*, not because I think there are only two genders, but because queer culture and straight culture still seem like two different zones to me. It is probably no accident that my current partner, the gardener, is also a Buddhist priest who spent much of his life living in various Zen centers and a few different countries before we met. We share the experience of living outside of social norms and of being deeply committed to practices that don't guarantee material rewards. (A relative once asked me, about going to an artist's residency, "What's the deliverable on that?") We feel a bit liminal in this world, and we like it that way. I know that on the street we just look like an older white straight couple; our neighbors often refer to him as my husband, though he isn't. So there's that too—the peculiar feeling of being continually misread by the conventional perspectives of others. It's a strange price to pay, but that is where my desire path has taken me.

As Brown's career proceeded, she played more and more doctors, generals, and lawyers; the rich interiority of Molly Dodd, her waywardness and self-invention, were apparently not imaginable in a middle-aged woman with power. She loved her long-running role as Nina Sharp on *Fringe*, but, as she told the Television Critics Association in 2016, "the truth is that was originally a story about a female protagonist [Olivia, played by Anna Torv] . . . and the show turned into a story about [a] father and son [played by John Noble and Joshua Jackson]. Very often in this business, that's what tends to happen." About her role on the television show *Limitless* as the mother of the hero, she remarked, "*Limitless* is a lovely place to work, but all I do is kind of nod and get food."

When *Fringe* ended in 2013, Brown says, "I was getting offered . . . episodic stuff in TV, little arcs. . . . The problem [with episodic TV] is that you're hopping on a moving train, so, basically, nobody wants to hear from you. . . . They just want you to please do this and please do that, and don't ask anything." She felt she had had it with that kind of role. "It's too hard. It's too soulless. You don't really participate. You just fulfill a function. I felt I was really sort of done." She told her agent she would "figure out something else." She thought maybe she would do hospice work.

During a summer not long after this, she was at a Sundance playwrights' lab working on a play by Denis O'Hare and Lisa Peterson about the writing of the Bible—"a real crowd pleaser"—an experience, she says, that was "the best. There were no agents there, no managers . . . it was just us making things. . . . It couldn't be sweeter. At dinnertime, we talked about work, we talked about acting, in a way that you don't get to do much once you're out of school." When a call from her agent came in, she initially ignored it. But the agent kept calling, so she finally called back, whereupon she was offered the substantial role of Judy King that covered four seasons on *Orange Is the New Black*.

King, imprisoned for tax evasion, is multifaceted: wily, certainly

privileged and just fine with that, sometimes racist, also nobody's fool, brave, capable of great kindness, and, in one memorable episode, the enthusiastic instigator (in her seventies) of an MDMA-fueled three-way with another inmate and a guard. A polyamorist from way back, King has moves. In an odd twist of fate, when Brown joined the *Orange* cast, she found herself walking onto the set at the same studio—Kaufman Astoria Studios in Queens—where they'd shot *Molly Dodd* nearly thirty years before. She hadn't been back since. "At the time ['Molly'] shot there," she told the *New York Post*, "there were two of us—ours and Cosby's [show]." (Reflect on those trajectories for a minute. Or more.) In fact, the creator of *Orange*, Jenji Kohan, had thought of her because of remembering Brown from *Molly Dodd*. "Two other actresses on the show," says Brown, "both women of color . . . had exactly the same experience [of feeling that] they were totally finished. They weren't getting any work. They both thought, 'I don't want to do this anymore.'"

But then, for all of them, the phone rang. Brown says, "As a friend of mine said to me, the amazing thing about being an actor is that your life changes in a phone call."

Of course, what had also changed was the television medium itself. A cultural tectonic plate had shifted. When the once all-powerful system of the three major networks was unseated by streaming services and the explosion of scripted cable content in the 2000s, tremendous creative vitality rushed in. At the forefront of this vitality were women, queers, and people of color both in front of and behind the camera. Ryan Murphy, a white gay man, and Shonda Rhimes, a Black woman, for example, became two of the biggest movers and shakers that the industry had ever seen. Both revolutionized television's most entrenched forms (the melodrama, the hospital franchise, the horror story, etc.) not only in terms of the diversity of the casts, but also in terms of what television scripts could do.

With *Orange Is the New Black*, which was a major hit, Kohan brought to the small screen a range of female characters unparalleled

in television history: all ethnicities, all genders, all sexualities, and with a cornucopia of emotions, impulses, and moralities that were continually subject to change. As prisoners, their options were limited, but for the actresses, the show was a feast, as it was for viewers. Moreover, à la *Molly Dodd*, the show mixed comedy, tragedy, and all the emotions in between with abandon. Like a human being, the show wasn't ever just one thing operating in one narrow bandwidth of experience. It was, as Zorba the Greek once said of life, the full catastrophe. None of the characters in that prison, including the people who run it, has a good career, a stable life, or a five-year plan. Nor do we, in the audience, expect them to, which actually seems to me like good news, culturally speaking.

When I watch Brown as Judy King, what I see so clearly is the same resilience, the inner freedom, that was visible in her forty years ago. As the world has turned over more than once and as she has gone physically from youth to older age, that fundamental quality in Brown has remained. If Roni Horn looks like different people in the series of self-portraits titled *a.k.a.* or Ye Jinglu seems to change radically from year to year, that is only if one views these images a few at a time. When they are viewed as an entire series, even without an accompanying placard, one has the strong sense of a continuous soul moving through time. It isn't something one can see per se; it's a feeling. With Brown, it's also a feeling in the audience she creates, the shadow she throws. The shadow has only gotten stronger. Judy King may be in prison, but the prison isn't in her, so to speak. When Brown plays her, we believe that.

I ask Brown what's up next for her. She's interested in more theater work, but theater generally hadn't really come back, postpandemic, when we talk. Most recently, she was offered a role in an HBO series playing the wife of a retired cop in Queens. "Literally, [her lines were,] 'Would you like this, dear? Can I do this for you, dear?' The whole part was that."

She turned it down.

Exile

In his essay "Exiles," the Chilean writer Roberto Bolaño states, "Exile, in most cases, is a voluntary decision. . . . The writer enters the labyrinth voluntarily—for many reasons, of course: because he doesn't want to die, because he wants to be loved, etc.—but he isn't forced into it." This seems existentially rigorous nearly to the point of absurdity, also demonstrably untrue. Not wanting to die is so primal an instinct that it can hardly be called a choice; many exiles are not at all voluntary, for example, Ovid's. Or Alexander Solzhenitsyn's. Or that of people fleeing a hurricane that destroys their town. Et cetera.

As the essay goes on, however, it beomes clear that Bolaño sees exile as a painful, but exhilarating, liberation. "A writer outside his native country seems to grow wings," he says. He speaks about it as a quest for individuation more than a physical state having to do with geopolitical borders. "For some writers exile means leaving the family home; for others, leaving the childhood town or city; for others, more radically, growing up." That he sees adulthood as a more radical exile than, say, going into political exile, as he did when he left Chile in 1973, raises the bar considerably for what "growing up" might mean, and perhaps what it might cost. True adulthood, Bolaño suggests, involves decisions, entering labyrinths of one's own volition, loss, and, for artists, the acquiring of

wings—a fantastic addition that also sets one apart permanently from most of humanity.

In 2021, Tania León won the Pulitzer Prize in Music for her composition *Stride*. Also in 2021, Alejandro L. Madrid, a professor of musicology at Cornell University, published a biography of León called *Tania León's Stride: A Polyrhythmic Life*. León was born in Cuba in 1943. Her family was poor. Her mother, who was of African descent and worked as a maid, could neither read nor write. Her father, who was of Chinese, Spanish, and Cuban descent, worked for construction companies, chased women, and was often absent. León and her brother were raised by their paternal grandmother, Rosa Julia, whom they called "Mamota." Mamota, who worked for the Ministry of Commerce, was a powerful force in León's life. When León was born, Mamota gave her a toy piano. When León was four and tuning the family radio to the classical music stations, Mamota signed her up for music lessons. When León was ready to go to school, Mamota somehow found the means to send her and her brother to private school. Later, León's paternal grandfather paid her way at the Carlos Alfredo Peyrellade Conservatory. Mamota, who was also a seamstress, made elaborate outfits for León as a child, including a Carmen Miranda number, complete with headdress, when she was two.

When I ask León about what has sustained her over the long run as an artist, the first thing she brings up is the photo of herself in that Carmen Miranda outfit, which is included in Madrid's book, painstakingly sewn by Mamota. "She would like to dress me into different characters that perhaps she loved, you know?" She continues, "I still feel like that child, [that she's] inside of me, looking out of my eyes. Sometimes I might be involved in big things, or conducting an orchestra, and suddenly I think, 'Oh my God, what am I doing?'" She is seventy-nine years old, a distinguished conductor, composer, and CUNY professor emerita with a résumé that could wrap around the globe a few times, as her career has

done, and she laughs at the image of this little girl in the costume sewn by her grandmother.

But she is also making the point that her grandmother's imagination, an imagination into which she literally sewed her granddaughter, gave León the impression very early on that she could be someone different, that the world was bigger than what she saw every day. Mamota, who also practiced Santería, was a Marxist, and an avid follower of the arts; in other words, she saw beyond what is to what could be.

León seems to have shared her grandmother's temperament. As a child, she was fascinated by the television series *Flash Gordon* and Flash's travels in the universe; she declared to her family that she wanted to be an astronaut. At nine, one of her piano teachers sent her a postcard from Paris with a picture of the Eiffel Tower on it. From that point on, she was determined to get to Paris.

In 1967, when León was twenty-four, she decided to leave Cuba to realize that dream. By this time, she was married and working as an accountant. The revolution had come. León's exit from Cuba was made possible by the Freedom Flights to Miami that started during the Johnson administration, along with the support of a Catholic organization that was critical of Castro. León didn't have a plan to get from the United States to Paris, just the determination to do so, because she was sure it was her destiny. "I wanted to be the best pianist," recalls León. Her ambition was to study in Paris with music teacher and conductor Nadia Boulanger, who taught the likes of Virgil Thomson, Aaron Copland, Philip Glass, and many others over her highly influential career, which spanned much of the twentieth century. At that time, says León, "Composition didn't have anything to do with my life."

Before León left, she taught her mother to read and write so they could exchange letters. Her mother was in favor of León's plan. Mamota, who supported the revolution, begged León not to leave, and warned her that they would never see each other again if she

did. León said, "You made me believe in this. You gave me wings to fly and now you do not want me to fly." Besides, she said to her grandmother, "if it doesn't work out, I'm coming back." The next day, however, as León prepared to board the propellor plane to fly those crucial ninety miles, the official to whom she gave her passport canceled it, as he did everyone's, to León's shock. At that time, as far as the Cuban government was concerned, leaving Cuba was a one-way gate. From that moment on, she was no longer a Cuban citizen. For the next five years, she wasn't a citizen of any country, until she could finally apply for American citizenship.

When León's plane landed in Miami, she didn't speak English. She had no money. She never did get to Paris to become a famous pianist. Certainly, León has been to Paris since 1967. But once she left Cuba and became a woman without a country, her life exceeded the boundaries of her grandmother's imagination, and her own. From the moment her passport was canceled, unbeknownst to her then, her life as a composer and conductor began.

However, Mamota had been right. She died four years later without seeing León again, nor was León allowed to return to attend her funeral. León couldn't go back to Cuba at all until 1979. Her music wasn't played in Cuba until 2010. She didn't conduct in Cuba until 2016, at seventy-three.

———

Is exile, literal or figurative, always a part of making art, as Bolaño argues? I don't want to think so—among other things, it feeds into the cliché of the tortured artist—but it also seems to me that some sort of intense velocity is required to hurl a person out of the orbit of conventional life and into the weirdness of art as vocation. Maybe you walk away of your own accord, or maybe you tumble onto the road; either way, you find yourself outside of town. Flash Gordon, after all, was also an exile, kidnapped by a mad scientist

who takes him to another planet; he becomes a superhero, an adventurer, but he never returns to Earth for any significant length of time. He wanders the galaxies forever.

Another fan of Flash Gordon was the sculptor Ruth Asawa, born in 1926, who found him not on television but in comic strips in the 1930s. Asawa was the daughter of Japanese immigrants who became truck farmers in California, although due to the Alien Land Law of 1913, they couldn't own land. Ruth Asawa knew she wanted to be an artist by the time she was ten, drawing and crafting in every spare moment from chores and school.

In 1942, when Asawa was sixteen, the entire family was sent to an internment camp, first in California, then in Arkansas. Asawa's father had been arrested earlier as an "alien enemy" by the FBI, and the rest of the family didn't know where he was for years. When Asawa left the camp to go to college, she was forbidden to be anywhere near a military zone, which included all of California. She attended Milwaukee State Teachers College, which had a program for prospective art teachers, and lived and worked with a family there as a maid. Asawa was a US citizen but she was treated as an interloper, her ability to move freely severely hindered, continually under suspicion. When she left the camp to go to college, half of her family was still imprisoned. She was in many ways an exile, a displaced person, within her own country.

Asawa was planning to become an art teacher, but, as her biographer Marilyn Chase recounts in *Everything She Touched: The Life of Ruth Asawa*, "as she prepared for the year of practice teaching, as required for her degree and credential," the school informed her that, in Asawa's words, "they would not assign me to a teaching position for my safety." Or, as Chase puts it, "Wisconsin schools weren't ready for a student teacher of Japanese heritage." Her time at Milwaukee State Teachers College, and all those hours as a maid, had been wasted. Meanwhile, Milwaukee friends of Asawa's who were studying at the freethinking art school Black Mountain

College in Asheville, North Carolina, had been encouraging Asawa to apply. She had planned to stay on the more practical teaching path, but since that was now blocked by racism, she applied to Black Mountain. There, she became a protégé of the Bauhaus painter and designer Josef Albers; studied with Buckminster Fuller; built props for a theater production featuring sets designed by Willem de Kooning, John Cage on the piano, and Merce Cunningham dancing; and met the man who would become her husband.

By the time Asawa died in 2013, she had become famous for her abstract sculptures made of copper and brass wire, often suspended from the ceiling. Some are globes or other rounded forms, but the most iconic of these are very long skeins of wire mesh that swell into ovals, distended diamonds, and teardrop shapes. They float in the air, looking like jellyfish on a string or minarets in a line dance, transparent, elegant, the wire both tensile and ethereal. No small part of their beauty is the complex shadows they throw, two-dimensional images in constant conversation with three-dimensional forms. She also sculpted trees with metal wire, and forms that look like tumbleweeds, the heads of dandelions, or lengths of lace. The going price for an Asawa is now in the millions.

Chase draws a convincing connection between Asawa's time in the internment camp and her sculpture. She writes that "the swords-to-plowshares metamorphosis of wire turned into art can't be ignored. Wire studded with barbs surrounded her teenage years." She goes on to quote something Asawa wrote in a notebook: "Wire can play." Following Chase, it is as if the gaze that looked out through those chain link fences of the camps later transformed the barriers into lightness, dance, and biomorphic curves. But it might also be said that Asawa never stopped bending those fences or seeing them. In a photo taken by Imogen Cunningham of Asawa at home in 1957 with four of her six children, enormous floor-to-ceiling versions of the long, curvilinear wire skeins domi-

nate the space. All her life, she kept wire, radically reshaped by her, close at hand.

—

"The novelist doesn't choose his [*sic*] themes," writes Mario Vargas Llosa in *Letters to a Young Novelist*; "he [*sic*] is chosen by them." He continues to say that life "inflicts themes on a writer through certain experiences that impress themselves on his [*sic*] consciousness or subconscious and later compel him [*sic*] to shake himself [*sic*] free by turning them into stories." This makes intuitive sense to me. Unlike the mother in my first novel, my mother did not commit suicide; it was her mother, my grandmother, who did, when I was in grade school. She used a gun. But this single, terrible act was part of a larger, more amorphous darkness that lurked everywhere and of which we did not speak. Something had caved in somewhere, and it was still caving in.

In my family of origin, over several generations, severe mental illness and equally severe addiction have taken people away, often for good. If they do come back, they are never the same. I have always had a great fondness for visual images in which a shape or line or face is cuspy, either on the verge of appearing, or disappearing. My wish, and my nightmare, in one. That darkness is unpredictable, powerful, and I have feared that it would take me, too, all my life. It is as if the bullet that took my grandmother, and the force in her that propelled it, has never stopped traveling. I never forget that that force is part of my ancestry. There are many reasons that I chose not to have children, but the sharks swimming in my gene pool are certainly among them.

In my work, this has resulted in a continual fascination with scale, particularly in the form of events or circumstances that are too big for ordinary people to manage or even understand. In my novels, again and again I have written about the aftermath of

situations that are overwhelming: suicide, madness, chronic illness, fame won and then lost, the damage from crime that continues to grow. The place where my books begin most of the time is a shock to the system that blows the system apart. People are, in effect, exiled from their own former lives. People go missing. Lives break. Identities shatter. *How did they live after that?* seems to be what I feel called to imagine, what gets me to the page. Probably, it is the story of this book, too.

Bolaño, as we've seen, rejects Vargas Llosa's sense of being chosen by one's themes, having a wound inflicted, by insisting that he, and others, choose exile, entering its labyrinth "voluntarily." He also leaves out an aspect of exile and displacement that certainly seems to be part of Asawa's and León's trajectories: the exiled one tells the story of that loss over and over, perhaps in many different ways, throughout a lifetime of work. To me, it seems to be the case that one day we are jolted awake to find ourselves in exile's labyrinth, and we begin making whatever it is we make not only to escape the labyrinth, but also to show other people what it looks like. In my life, the sense of exile has been affective, not geopolitical, and I've never gone hungry, had to leave my country of origin, or been imprisoned. I have just felt a deep apartness, a markedness. Our house had a threatening darkness in it that others didn't (or so it seemed to me, as a child), and I'm queer. Several times, I've wondered how I would live. At the same time, the conditions over which I had no control have also proved to be the forces that have given me, respectively, my life's work, and my life.

———

When León got to Miami, she recalls, other people from the plane were kissing the hand of the priest who welcomed them, but she had "never been so frightened in my life. It's like when you open a door and there is a vacuum or a precipice." People who left Cuba at

that time were widely scorned back home by the many true believers in the revolution. In Miami, the Cuban exiles were extremely anti-Castro; León's less doctrinaire politics often isolated her in that community as well. When she called home, government eavesdroppers were listening. She stayed with friends in Miami, but because she couldn't speak English, the only job she could get was working as a cashier at a Publix supermarket. She couldn't go home, and she couldn't make much of a new home where she was. She'd lost her family; since she couldn't return to Cuba, as Madrid puts it, her "marriage was, in practical terms, over"; she couldn't follow her aspiration to study with Boulanger in Paris. She couldn't even speak freely to Mamota on the phone. There was no visible way forward and no way back.

But by the third day at the Publix, León tells me, "I said, 'I'm not staying here. I want to go to New York, that's where the music is.'" And she did.

In conversation, León is blithe, warm, and open. I can almost forget that we're on Zoom. She laughs a lot. She wryly refers to her problematic father, long dead now, as "a nut head" who was out dancing and drinking the night before he died. Despite her stature in classical music, she feels like the kind of person one could just hang out with, telling stories. However, in the 1993 Michael Blackwood documentary *The Sensual Nature of Sound*, León crisply conducts an orchestra as they play her piece "Indigena," instructing the musicians, "Give me everything you have, and then tomorrow, you give me more." She says this in the even tones of one quite confident in her own authority. She doesn't need to yell or bully; she fully expects the musicians to do just what she told them and one imagines that they did. What else is there to do but give everything you can?

León got to New York, where she lived with friends in the Bronx and found what work she could—some accounting, some messengering. She was also offered a scholarship to study at the New York

College of Music. She was putting a life together, but in 1968 that life took a major turn. Hired for the day as a substitute accompanist for a ballet class in Harlem, she noticed a handsome man outside the classroom. Later that day, he turned up again, and as he came toward her where she sat improvising at the piano, she felt an extraordinary force coming from him, a leonine energy like nothing she'd ever seen in her life. He asked for her number, and she thought, she says, "What is this?"

As it turned out, he wanted her number so she could accompany his ballet classes. He was Arthur Mitchell, the first African American to join the New York City Ballet, in 1955, and the first African American to be a principal dancer in any important US company at all. When he met León, he was on the cusp of creating Dance Theatre of Harlem. He hired León as the still-unnamed fledgling company's pianist, but then he did something that would radically change the course of León's life: he told her to improvise during dance lessons, that he would create choreography based on the music she was inventing on the spot. Within two years, she had written her first original composition for a new ballet Mitchell was making called *Tones*. As León told Madrid, "He created *Tones* in front of me. I mean, every portion of it [we did together]. . . . I had never [formally] studied composition. . . . I went down to the library and checked out some music theory and composition books, and I learned by myself from them how things worked. That's how I wrote that ballet."

While it seems likely that León would have bloomed wherever she was planted, it's difficult not to feel that a serendipitous series of events conspired to ensure that she met Mitchell. If her friend who had been the regular accompanist hadn't gotten sick one day and asked León to sub; if Mitchell hadn't been passing by the classroom and heard her playing; if she hadn't stayed after class; if he hadn't been passing by again. If she hadn't lost her country and her passport, effectively stranding her in the United States. All of

these forces—some benign, some cruel—came together so that on a summer day at a church on West 141st Street in Harlem, one extraordinarily talented person would pass by a room where another extraordinarily talented person was playing the piano, and a composer would be born. Not Boulanger, not Paris, not the life of the solo concert pianist, but rehearsal spaces in churches, sweaty dancers, and a collaboration that helped create not only a composer but also a choreographer.

Boulanger famously saw her rigorously selected pupils at her family's apartment at 36 rue Ballu, in Paris, which featured two grand pianos and a wall filled with framed photographs of various cultural leaders—a far cry from the crowded, wildly underfunded, improvisatory world of the early years of Dance Theatre of Harlem. Young though it was, however, people like Cicely Tyson, Geoffrey Holder, and Marian Anderson were lending their talents to it early on. León spent the next ten years as music director for Mitchell and Dance Theatre of Harlem—traveling widely, continuing to compose, beginning to conduct. In Madrid's book, there are photos of León with Leonard Bernstein, Marian Anderson, Nelson Mandela, Wole Soyinka, Henry Louis Gates Jr., the Queen Mum, Tito Puente, and many other luminaries.

The adjustment to her new life, however, was far from easy, particularly in León's early years with the company. She had to become fluent in English. There was a second marriage that didn't last. Mamota died. For the five years until she could get a US passport, León was frequently stopped at international borders when traveling with the company. She had to come to terms with the way race is mapped in the United States. Madrid writes that, "as a foreign woman of color, she was perceived by black and white people alike as a black woman, regardless of how she saw herself." So much of her hair fell out during this time that she began wearing a wig.

In 1979, León was finally able to visit Cuba. According to Madrid, it was a profound, but roiled, return. The Cuban government had

made sure that none of León's accomplishments were known there. Mamota was gone. Her three-year-old nephew thought she talked "strangely." The country had changed, her family had changed, and she had changed in the twelve years since she had boarded that propellor plane. Her father showed up, then didn't, then did, and after hearing her music, he asked, "Why don't you use something in your work that is ours?" When her father didn't make it to her farewell dinner, León left Cuba angry; three months later, her father died.

It was at this point that León, for the first time, began threading into her compositions "elements of Cuban music that would appear in my later work," as she told Madrid. She continued, "I felt an explosion inside me. I realized that there were very cherished things in me that I was denying. And I felt the sounds of my environment, the sounds of my childhood, starting to come back to me." She wove in Cuban dance rhythms and the sorts of West African drums played during Santería ceremonies. She used the cello as a percussion instrument. She used the speech rhythms of people she knew back in Cuba. She explained to Madrid that a piano section at the end of her 1991 composition "Indigena" "is the plane leaving Cuba." Once she incorporated these elements, they became an integral, distinctive part of her musical voice. After that visit to Cuba in 1979, León tells me, "my music shifted completely." She bent Cuba, stretched it, transformed it into the abstractions of her chosen art form. Cuba might have erased her, but she did not erase Cuba.

Moreover, once again, León rose to meet a challenge thrown down by a charismatic man, a call to expand her voice in a crisis moment of ambivalence and loss. When she met Mitchell, she was a woman without a country; when she reunited with her father, she was not only no longer a Cuban citizen, but she was also permanently set apart from her family and the country of her birth. It seems as if the moments when she felt most keenly the hard edges

of her exile were also her moments of musical breakthrough. When I am talking to her face-to-face, she might seem like a neighbor, buoyant, menschy, but when I am not looking directly at her she also seems like a pearl diver, one who can retrieve treasure from great depths on one breath.

What is the source for that pearl diver? If I consider, however amateurishly, León's career, I can see the talent, the tenacity, the syncretism of multiple musical forms and sounds, and the ability, so important in composing and conducting, to work with others and draw the best out of them. But while I can see the pearl diver, I can't see what made her. There is brilliance in the music, but there is also a quality in León that might be best suited to discussion in spiritual terms: at certain moments, under maximum pressure, her soul shone forth, visible and undisguised. When I comment to León that musicians seem like magicians to me, with abilities I can't fathom, she replies that everyone who does something different than she does seems that way to her—the cobbler, the politician. "It's like everybody is a certain god walking around," she says.

In her interview with me, and with others over the years, León emphasizes the difference between the physical form and the essence of a person. We have only been talking a few minutes when León says, "I believe in the life of the spirit, because there's something that talks in me." She continues, "I'm not what I look like. This is only my costume." In an article written about her for the *New York Times* in 2020, writer William Robin quoted her saying in 1986, "I am nothing that the people want to call me. They do not know who I am. The fact that I am using this physical costume does not describe my energy, does not describe my entity. My chosen purpose in life is to be a musician, a composer, a conductor. This is the way I am making my contribution to mankind." Nearly forty years later, she said the same to Robin: "I honor all my ancestors in my skin, and in my character, and my presence," she said. "But I don't go around saying I'm Cuban-Italian, or I'm Cuban-French, or

I'm Cuban-this and Cuban-that." In an interview with Isabel Merat for *Opera Culture* a few years ago, she said, "It is very hard for me to define myself when I am changing every day. We change every second, change is the only natural thing that apparently is happening on this planet everywhere. I am not going to be against change, I am trying to adapt as much as I can. I am not the same person."

León is often placed in identity contexts: Cuban, woman, woman of color. Her Pulitzer was awarded for a composition commissioned to commemorate the Nineteenth Amendment. In 2017, her piece "A Tres Voces" for violin, viola, and cello was part of a New Gallery Concert Series titled "Identity," a program described as "music and visual art in conversation with race and the struggle for equity." She has expressed her discomfort with being seen only as a representative of categories. León speaks about identity the way Blair Brown speaks about her "NBC tits": an unnecessary appurtenance, a costume created by others for their own purposes, not hers.

When I talk to León, it is the unbounded life of the spirit that she cites as a creative wellspring. She says, though, that it is a "very deep area that I rarely discuss, because [with] people coming from the islands or other places deemed exotic, there are always these judgments and these labels placed on them." She meditates frequently, and says she follows the "Buddhist line of thought." She laughs when she tells me, "Some of my friends have said that one of these days they're going to come over and find me walking around with a pyramid on my head."

León seems to feel herself to be a Someone who has found herself in a costume—Carmen Miranda; this body; a citizen of one country, then another—which is essentially temporary, often constructed and interpreted by others. She is relaxed and respectful about this costume, but she doesn't conflate it with her very being. She, and everybody else, is a certain god walking around, momentarily enclosed in this or that corporeality. "Why do we classify

people one way or the other?" she commented to Merat. "There is so much classification, and unfortunately due to that classification, also in my estimation, there has been a lot of abuse of one group towards another."

León's resistance to classification includes her personal life. In 1989, she met Martha Mooke, an electric viola player, and they stayed together as a couple for the next thirty years. Mooke, an avant-gardist who has also worked with musicians such as Iggy Pop and David Bowie, seems to come from several worlds that are different from León's, though she has produced some of León's CDs. Mooke grew up in Staten Island and has worn many different hats as a musician, producer, teacher, and arranger; she founded a program called Multi-Style Strings at New Jersey City University for boundary-pushing work by string musicians. While it's more or less impossible to know what goes on between two people over so many years, on the surface one can see the outlines of this couple: one, exiled, classically trained, part of the Cuban diaspora, by necessity and temperament a global citizen; the other, a Jewish, lifetime New Yorker who took her viola electric and has chiseled a career as sui generis as her music. As Mooke has said, "I never accepted limitations and boundaries no matter what I was doing, whether it was because I was female or because whatever. . . . I found opportunities. If the opportunities don't exist, I make them." León was hired by Brooklyn College in 1985 and stayed there until her retirement as professor emerita in 2019. Mooke has taught around the country in addition to performing with the likes of Barbra Streisand, Elton John, and Tony Bennett. León has always been high art. Mooke works the edges between new music and pop as well as other musical genres, and added a fifth string to her electric viola.

Because their separation was fairly recent when I interviewed León, I felt that I needed to tread carefully when asking about Mooke. But I was also frankly curious. What scenes might they

have been in together; how did they influence each other's work; what was the effect of their skin-to-skin relationship? When I bring her up, León only says, "Well, you know, I've been thinking that I have never lived fully my personal life. I've dedicated my life more to what I have been doing in the arts." There is no regret in her voice when she tells me this; she's simply stating a fact. She continues, "It's not even to have a great career. It's because I love music, you see?" She goes on to say that she has always kept her personal life "aside," no matter who she was seeing, and she reminds me, "I still have that situation that I don't like categories. I'm not cemented into one thing."

Instead of any categories, León cites the energy of her ancestors as a vital source for her. "They are around," she says. "They are present, or something. I mean, don't ask me what that is." But she feels it, she tells me. "It passes by, and my eyes get watery. It is very strange. It's fantastic." León is the first to acknowledge where these ancestors lived and died and under what specific conditions. However, given everything else she has said about essence versus form, my image of these ancestors is of energies far larger, deeper, and less individuated than their identities in life, like the underwater roots of islands. It's a difficult vision to hold, here in our identity-driven cultural moment: the both/and of an ancestral energy that is history-bound and far deeper than human history at the same time.

But I think that's what León is saying to me, and has been saying, all her life, about what it feels like to be her. Like music itself, she is produced and made visible by a body, but she goes far above and beyond and beneath that instrument. The music of a guitar is not coterminous with the fingers that pluck the strings. The fingers make the music audible to our human ears, but we can't understand or even experience that music by analyzing the physical composition of those fingers. She told Madrid, "Sometimes I'll come back to a score days after finishing a piece and there are whole sections that I cannot identify or remember writing. I seriously wonder, 'Who

wrote that?' I don't know. It feels like someone else came in at just that moment and wrote that passage, or that entire section."

===

One evening, I have the pleasure of seeing León conduct the chamber orchestra of the opera *Hometown to the World*, with music written by Laura Kaminsky and a libretto by Kimberly Reed, at Town Hall in New York City. The opera concerns the aftermath of an actual raid by the Immigration and Customs Enforcement in 2008 of a kosher slaughterhouse in Postville, Iowa, and the political organizing and struggling that ensued.

The chamber orchestra is all in black, and their part of the stage—Town Hall has no orchestra pit—is dim, with just a small yellowish light on León and her score, studded with sticky notes. On the spotlighted part of the stage, the characters sing woefully of "a lot of cheap meat" and, at the hopeful finale, exalt collectively in the phrase, "Today I repair the world." Meanwhile, León and the orchestra appear to be having a wordless conversation they've had before. León has a baton in her right hand; her left hand moves like a bird on the currents of the music. She leans forward slightly; she smiles; she nods; her eyebrows raise and lower; at certain points, she smiles broadly, as if to say, "That's it! Yes!" At one moment, left hand aloft, her thumb quivers in the yellowish light. I know the quiver means something, even if I don't know exactly what that something is. The pointer finger on her left hand, however, is where all the action is. It goes up, down, and sometimes makes a stabbing motion that seems to mean *Push!* or *Go!* She is elegant in a flowing black-and-white ensemble that looks a little like a sleeveless tuxedo floating down a river. She is also wearing thick black clogs of the kind worn by medical personnel and other people who spend hours on their feet.

On the brightly lit part of the stage, characters are experiencing joy

and despair, organizing, arguing, trying to understand one another. On the dimly lit part of the stage, the musicians and León seem to be one multilimbed being, trying to get over a hill they've climbed before. Or perhaps across an ocean, rowing together. These spheres are obviously not only contiguous but also related—now and then, the performers look at León for their cues—and at the same time, they do not quite seem to occupy the same dimension. On the bright side are distinct personalities with specific desires and sorrows; a drama is playing out. On the dim side is a group of people whose outlines blur, hands and faces just visible in the shadows, with the focused expressions of people who are listening intently. The music itself seems to mean something different on the different sides of the stage. On the bright side, it illustrates moments of triumph or contention; on the dim side, it has ridges, valleys, and clouds.

Like Asawa's ethereal skeins of wire, the music, and the way León conducts it, is a complex interplay between use and abstraction. Wire can play. So can sound. In the opera, a whistle blows. On the bright side of the stage, it is a call to protesters to assemble. On the dimly lit side of the stage, it is a blurt, a bleep, a shout of joy. As the protesters rush onto the stage, León smiles broadly. I just don't have the feeling that she's smiling because of an antagonism toward ICE, however justified that might be. It occurs to me that I may have been watching a structured, rehearsed performance with specific thematic points that was also a summoning, a journey to an open-ended, many-faceted Elsewhere. At the end, I go to congratulate her and she leans down from the stage, her arms filled with flowers, smiling, sweating a little, breathing hard.

Despite León's warmth and approachability, I have to admit that I am intimidated by her music. I feel out of my depth. At first, when I begin listening to it, I pay a lot of attention to the titles, word-oriented person that I am. For example, "Toque," dedicated to Mooke, means "touch"! That must mean that it's some sort of love song, seduction or praise, right? Or, if I were a musicologist like Madrid, I could ask

informed questions of this and other pieces, like, "What about that
G-major chord in measure eighty-five?" and speak knowledgeably
of "León's use of octatonic sonorities." However, I don't read music,
and I wouldn't know an octatonic sonority from a giraffe. Instead,
I try to listen, drawing confidence from what León has said to me:
"I always say that Beethoven didn't call his music 'classical.' He just
called it his music." She would, she says, put the music of Toscanini
next to "the lieder of Mozart or Schubert and 'Sophisticated Lady'
by Duke Ellington. All of them are classical."

What I hear is kaleidoscopic, as when you shake the kaleido-
scope and different patterns emerge, come apart, and reemerge,
differently. León has said that her piano piece "Tumbao," for in-
stance, was inspired by her father's gait. She took that gait and trans-
formed it: a particular bouncing, loping rhythm comes and goes,
appears and disappears, interrupted by trills and gallops and some-
thing that sounds like a very tiny deer running on tippy-toes over the
keys. "A Tres Voces" is filled with sliding, circling, gliding notes
that shatter into flurries and then come together again, after un-
expected pauses and stops. Perhaps "Toque" is a love song, but the
sound that stands out to me is the marimba with its woody rever-
berations, which is used often in this piece. Like Georgia O'Keeffe's
hands, that sound of the marimba feels like the shadow thrown by
an intimacy that we can't see. The piece is decentered, like a Jackson
Pollock painting, its rhythms pulled apart, scattered, then reconfig-
ured, a conversation among chords and single notes, rhythms joined
and disbanded, that reminds me of dancers moving together and
moving separately in the unpredictable choreographies of modern
dance. The rhythms aren't regular, but you can dance to it, if you
move as it moves.

I found myself thinking of David Bowie. This may be in part
because I'd been looking at photographs of Mooke with Bowie at
Carnegie Hall in 2002. She looks radiantly happy; he looks, as al-
ways, possessed of a physical beauty that is also somehow unearthly.

He seems to be a lightning rod of his own existence, as if Bowie energy was flowing through the universe in search of an appropriate vessel until it found David Robert Jones in Brixton in 1947 and then: *kapow!* The analogy is not exact. Bowie's energy is almost supernaturally cold but also explosive; León's is warm, modulated, and rigorous. But if anyone could be called "a certain god walking around," it was Bowie. What god and from where? God of what? We still don't know. The existential astronaut Major Tom wandered the universe, too, an exile from Earth not only in body, but also temperamentally. As beamed via early Bowie, glam rock came to us shimmering with so much wild surrealism that it ventured into the metaphysical, the transubstantiated. He shape-shifted over the course of his life, and his art, but an essential strangeness was always part of his energy. Even when he looked so perfectly the part of the elegant older gentleman during the Tin Machine era, and after, one had the sense that it was a costume, that his parti-colored gaze was looking out of a construction. He always seemed more collage than man. *You don't know who I really am* is the story he told us again and again. What was his exile's labyrinth? Was masculinity his Cuba, the place from which he came but to which he was always renegotiating his relationship? All I can say is that when I look away from the impeccably self-curated images of Bowie, I see a melancholy that, of course, may or may not be there.

Still, as Bolaño wrote, there are those fabulous wings the exile can grow. One time when I talk to León, she is leaving for Switzerland the next day. Another time, she is getting ready to be filmed by PBS, because she's about to be named a Kennedy Center Honoree. Several months later, I will watch her conduct the orchestra for a special performance by Judy Collins looking back on her own very long run.

"This planet," León tells me, "is something."

The In-Between

Before I interviewed the painter Amy Sillman for this book, I had met her twice before. The first time was in the summer of 2001. I had just broken up with J and I had to find somewhere to live, fast. I saw a miraculous ad in the *New York Times* for a ridiculously affordable one-bedroom sublet in SoHo. I thought it couldn't be real, but when I got there, the apartment was lovely—and it had just been taken. The writer of the ad, who said she was an artist, looked at me in my clear disarray, and said, "I'm going to help you." She had some artist friends in Williamsburg, Brooklyn, who were looking for a roommate in their vast live-work space, she said, and gave me a phone number. That space turned out to be thousands of square feet, with double vaulted ceilings, behind the battered, graffiti-scrawled doors of a warehouse. The available room had floor to ceiling industrial windows. It was one of the most beautiful places to live I had ever seen, and it saved my life. In New York, real-estate kindness is a mercy greater than nearly any other. I never forgot that artist—who was Sillman, of course—and her generosity to a stranger who probably gave off the vibes of a total crazy person.

The second time I met her, in a sense, was in 2017, when I wandered into the Drawing Center in New York. In the basement was a five-minute video installation by Sillman called *After*

"Metamorphoses." I sat down to watch. Here is what I wrote about it for a piece I published in *Catapult*, an online magazine:

> The hand-drawn images morph and remorph at a rapid rate: rocks into people, tree into scarab, peacock into bull, woman into bird, bird into horse, cat into bat, woman into spider, flower into dolphin into pig, two men into two trees, woman cuddling dog who turns into lion into bird into snake, male and female figures who embrace and become an androgyne, cat into owl, a woman with foxes coming out of her mouth, a man and woman on a mountain who turn into birds in flight. Other things flicker past: phallus-y shapes, a child's face, a female figure with a spear (Diana?). The changes happen so quickly that they border on the subliminal, which may be part of Sillman's idea about how we experience fundamental change: We're halfway through it before we're even entirely aware of what's happening.
>
> In her video, it's as if we're seeing thought enacted, a mind beneath the images making associations and decisions, shaping and reshaping the matter of matter into other matter, fast and fluid as fingerpainting. I watched the video four times and still couldn't catch it all. In the issue of Sillman's zine *The OG* that accompanies the exhibition, she writes, "Our desires is conflicting and ill-fitting . . ." I like to think that the "is" isn't a typo. Our desires *is* conflicting, and our minds change continually. Or are changed, by forces we can't control.

In an essay called "Shit Happens: Notes on Awkwardness" that Sillman published a year before I happened upon her video, she wrote, "I think it is a kind of metabolism that drives me to change and change and change my forms, searching rather earnestly for something I don't quite know already, a kind of questioning machine, endlessly discontent."

Sillman is most often described as a painter, but she has also worked in video, animation, installations, and multimedia; she has published numerous catalog essays, articles, and books; she is also known for her very funny seating diagrams: rectangles at which guests are identified not by name but by their psychic configurations, such as "crippling doubts," "malignant narcissism," "extreme sibling rivalry," and "morbid fear of body invasion."

She was born in Michigan in 1955 and grew up in Chicago. Her father was a traveling salesman and her mother was, as she says, "a 'fifties housewife." She went to Beloit College in Wisconsin, dropped out to travel and have "different kinds of adventures" with a friend, then went to the School of Visual Arts in New York, where she got a BFA in 1979. Later, she went on to Bard, where she got an MFA in 1995. She began teaching at Bard in 1996 and stayed on the faculty until 2013. She taught at the Städelschule in Frankfurt from 2016 to 2019. In 2019, faced with the decision to stay with the Städelschule on a permanent basis or return to New York, she came back to New York.

I spoke to her in 2022, following a period that had been notably productive and successful for her as an artist, even as the world was being knocked sideways by the pandemic, Trump, escalating climate change, and other brutalities. In 2019, at sixty-four, she curated a show titled *The Shape of Shape* for the Museum of Modern Art in New York. As Covid arrived, Sillman decamped to a rental on the North Fork of Long Island and drew flowers over and over at her kitchen table for the next year. As she told Jason Farago of the *New York Times*, "I wanted to place flowers around in the same spirit that you place flowers at a grave site. It's an act of having a living thing that's a memento mori." When that work was exhibited, the critic Hilton Als wrote in the *New Yorker*, "The splendor of Sillman's new show at the Gladstone gallery lies in its restlessness. . . . Her paintings of flowers . . . convey some of the lush despair and loneliness of van Gogh's sunflowers and irises but are mostly

about the spontaneity that is Sillman's stock-in-trade: the flowers are the visual manifestation of her blooming mind." In 2020, she was elected to the American Academy of Arts and Letters. In 2022, for the first time, she was invited to participate in the Venice Biennale. In the second half of her life as an artist, she says, "things have been kind of looking up."

Meeting her again—I in my living room, she on Long Island, each in our Zoom boxes—she is both wry and serious, with fashionable thick-rimmed glasses and curling gray hair. Behind her, the walls are white, bare, like gallery walls waiting for the next exhibit to be installed. She's quite forthcoming, thoughtful, and yet I have the sense of a shyness there. Often when we talk, she is looking down at something, as if she might be drawing while we speak. She chews her fingers from time to time, pushes her glasses up her nose. I am conscious of wanting to impress her, or at least not to seem like a dope when discussing visual art. Her intellect is deep.

I find her somewhat formidable, but writing by and about Sillman often highlights her lifelong emphasis on awkwardness, doubt, nonmastery, and humor, including the comedy of being embodied. As she puts it in "Shit Happens," "From the control tower of the head, one gazes downward, always downward, upon this 'loose, baggy monster' that we find ourselves in, this laughable casement that is the body below as ankles swell, farts are emitted, rolls of fat jut out, the penis does its own thing. Shit happens and then you die." Many have commented on the way this perspective fuels her fresh take on abstract expressionism. As Tausif Noor wrote in *Frieze* magazine in 2021, Sillman "recuperates abstract expressionism from the masculinist interpretations that have coloured it in recent years, insisting instead on its 'active embrace of the aesthetics of awkwardness, struggle, nonsense, contingency.' Its sense of discomfort fed her own painterly innovations."

One aspect of what this means on the canvas is that Sillman has been engaged throughout her career in a long, complicated

dance with abstract expressionism that frequently includes figuration, narrative, drawing, and the seriality of film strips or cartoon panels. Additionally, as Valerie Smith points out in her monograph *Amy Sillman*, one will often see an extended arm in Sillman's paintings: "the arm of the artist, the lover, the conjurer." Bodies come together and come apart in Sillman's work. Smith writes, "diverging bodies and protracted limbs lash out surprisingly with the precision of mechanical arms to grab, pinch, snatch, capture, hug or suffocate, creating unexpected humor from the interplay of cryptic forces." Sillman's canvases often have a tremendous sense of tension, with scrawled blocks of color abutting and intruding on other blocks of color, biomorphic forms, and suddenly, perhaps, that extended arm reaching out, unattached to any visible body.

The mix is complex. Forces drive this way and that, tangled and dense and propulsive. I return often to three works from 2017–2018—*Lift and Separate, In Illinois,* and *TV in Bed*—in which the outlines of two figures lie face-to-face, but separated by several horizontally stacked color bands. Smith likens these to "ancient burial rites" as well as to "a double associated with a ghostly self or a projected self." I find in them a deep sadness. They are so dense, so weighty. The figures seem as if they are already half-dissolved in the density, becoming part of the bands of color in which they are embedded, tracings that are already disappearing. When I bring these up to Sillman, she says, "What I think you're aware of, and that I'm also keenly aware of in those, is that they're paintings about loss. The loss is represented by basically empty space, which is in between, and the space is graphed out in a series of horizontal lines, which a writer would obviously relate to because that's what a page is. It's like a letter where you go, 'Dear friend' and then there's a blank space and at the bottom it goes, 'Love, Stacey.' And the middle is empty because it can't be named." She continues, "*TV in Bed* is basically me lying in bed and some dead person, or not-there person, and the subject is the space between."

I offer, "The figures frame that space."

"Yeah," says Sillman. "They're always moping."

That "space between," the unnameable subject, in Sillman's work, seems to well up from abstraction. She cites the work of an earlier abstractionist, Howard Hodgkin, as a profound influence. When she was in Madrid many years ago, she went to one of Hodgkin's shows, was "totally knocked out," then, bedridden with the flu, spent days reading the catalog from cover to cover. Hodgkin, born in 1932, always knew he was gay, but married anyway. In the 1970s, he went to India, became extremely ill, and, long story short, came out. Having been a fairly representational painter prior to this pivotal time, he then exploded into abstraction. As Bruce Chatwin put it in a piece about Hodgkin, after this explosion, "The sitters—though they still exist under layers of paint—are overwhelmed by dots, splotches, flashes and slabs of colour." In Hodgkin's dense later canvases, one can see those abstract flashes and slabs, stacked and packed like Sillman's. The colors, as Rainer Maria Rilke once wrote of Cézanne, "come to terms among themselves" in a conversation filled with serendipity and surprise. Like Darrel Morrison, coming out opened another door in Hodgkin's work, a door into a different mode of expression. As Sillman says, still excited all these years later to talk about Hodgkin, "There were all these synthetic, synesthetic, kinesthetic unlockings that were to do with confrontations with sex and death." For Sillman, as for Hodgkin, abstraction seems to be the place where we talk about what we don't know how to talk about, but without words.

Unlike Hodgkin, however, Sillman folds in figurative forms as well as media other than paint that, taken together, foreground a sensibility that roams around, continually combining and recombining elements as needed. When Sillman talks to me about her life, she also emphasizes awkwardness and improvisation. As a high school student, she recalls, "I liked the art class, but I was very intimidated by it. I didn't know how to get into the painting room.

I thought maybe I liked crafts, so I made pottery and drew pictures that were entertaining for my family." She liked it that her drawings made people laugh or illustrated a conversation. "I clearly was bumbling around. I just didn't know."

Many times in our conversations, she says "I didn't know" or "it was decades of bumbling around" or "I didn't know what I was doing." She says of her younger self, "I would always get adjacent to whatever I was thinking. I never knew how to go straight for it." She very much wanted to attend Cooper Union for art school, for instance, but was "too scared to apply." Instead, she went to the School of Visual Arts, initially applying as an illustrator. Once she transferred into the fine art department, she found teachers who turned out to be wonderful for her: Pat Steir, Sylvia Mangold, Jennifer Bartlett, Elizabeth Murray, Susan Crile. Nevertheless, "I was riddled with doubt," she recalls. "I was afraid of failing."

The upside of what she describes as a long apprenticeship period of randomness, self-doubt, and ignorance, however, was that "in a funny way, it was all so free." She muses, "If I had had a top-heavy education, like the Ivy League of the art world, I would have been a really good student and tried to get As and tried to do good work that was pleasing to the teachers. I would have sucked up everything they said and imitated them." As a result, she speculates, "I would have maybe been a more academic artist." Once she graduated from SVA, she got a job. It was New York in the early eighties, a time when artists and writers could still eke out a living freelancing. In Sillman's case, the freelance work was doing pasteup at various publications. Pasteup was what it sounds like: pasting text with hot wax onto large layout boards that were then photographed for printing. When I worked as an editor at the *Village Voice* in the 1980s, many of the people who worked doing pasteup were artists like Sillman; pasteup was their day job. They expertly wielded X-Acto knives and ran pages of copy through the rollers of the hot wax machine; they stayed until all hours in the large, windowless,

fluorescent-lighted workspace as copy was finalized and printed out. We editors walked around the room staring at the boards with deep concentration. If we found a mistake or needed to make a change, tiny bits of waxed text had to be printed out and carefully inserted by hand. Fitting text and keeping the spacing elegant was an art form in itself.

"I worked the equivalent of two weeks a month," Sillman remembers. "So if you worked sixty hours a month, and you made $25 an hour, then you'd make about $1,500 a month. You take home $1,200 after taxes. And your rent is, like, $100. And you take out $500 or $600 to live on—you can afford it." She worked for eleven years doing pasteup, teaching other people how to do it along the way. It was a robust economy. "You could always give your job to somebody or get a job from somebody or get your friend in."

That ecosystem basically vanished with the advent of digital layout using computers. By the early nineties, Sillman says, "I went, like, screw it. I'm going to go get a teaching job." Which she did, while also going to Bard in the summers for her MFA. Of all these early jobs, from pasteup to teaching, Sillman says, "It was so fun, because there were artists there." She cites an "esprit de corps," pointing out that "it's kind of lonely being an artist, so it's fun going to an office." Of her time much later in her career at the Städelschule, she also says, "It became really fun" and that being immersed in German painting and a different academic structure taught her a lot. Her aesthetic is one of awkwardness, but as a woman supporting herself in the arts, she seems to have been adept at finding her way, not least because she enjoyed the company of other working artists—a rarer quality than it might seem. As comedian Dana Carvey once wrote, "The reason 'class clown' is singular is because if there were two class clowns, one clown would ultimately kill the other clown." Artists, no less than comedians, can be quite competitive. Additionally, there is little about making art that necessitates liking to hang around with other artists. Many

fine artists—Joseph Cornell, Agnes Martin, Henry Darger, among others—were loners.

Sillman's trajectory also points up another aspect of thriving over the long run as an artist. Darwin's famous phrase "survival of the fittest" doesn't mean one has a better chance of surviving if one is physically fit. He meant "fittest to one's environment." If you are a creature who likes to eat snails, but you can also survive on berries, you'll be all right if the snail supply dries up. If you can do pasteup, and can make art while having a job, but you can also turn your hand to teaching, and still make art, you'll be all right when computers replace pasteup workers. Sillman, Tania León, Darrel Morrison, and Samuel R. Delany are examples of artists who are fittest to their environment in the Darwinian sense, because there is a fact about art-making in the United States today: universities are a main source, if not the main source, of employment for artists and writers. If you are an artist and you need to work to support yourself, chances are good that you will—if you're lucky—work at a university. In a 2019 paper funded by the National Endowment for the Arts, authors Amanda J. Ashley and Leslie A. Durham wrote, "Universities are likely the 'greatest arts patrons' in the United States, with an estimated investment of more than 5 billion dollars. . . . They are the places where most emerging artists receive their artistic training and skills. Universities support and invest in faculty and staff that oversee arts curriculum, they fund scholarships, they pay faculty who are artists in their own right, and they provide the research support and infrastructure for arts economic development."

Michelangelo had to be able to deal with the pope (which often did not go well). Artists and writers working now have to be able to deal with the dean (which also often does not go well). The names of the universities where artists and writers work may be different, but the institutional structure is the same: hierarchical, separated into discrete segments of quarters or semesters, credentialed and

credentialing, bifurcated into faculty and administration who neither work nor get paid in the same way, concerned with the formal education of young people, set apart from the surroundings on a campus, bureaucratic, with governing structures of its own, and, at times, quite a bit of secrecy. The university employs a great number people in collective, and sometimes competitive, relationships to resources and aims. Many campuses are entered through actual gates. Once you go through those gates, you are in a world that is not exactly like the world around it, with its own rules and consequences.

In order to be successful there, a particularly capacious temperament is helpful. "I loved my teaching jobs," Sillman says, even as she was making art, showing her art, and writing about art abundantly. In an interview included in *Faux Pas*, a selection of her writings and drawings, she says that at a certain point she realized that "my work as a teacher and co-chair of a department at Bard was part of my art work: it was very empowering and really startling to think of my whole life as the expanded field of painting."

Like Sillman, Tania León drew on the aesthetic river that flowed beneath her teaching and her own work. She was able to continue to compose and conduct during the decades of teaching because, she says, "I flip from one thing to another in the musical environment effortlessly. I enjoy everything to do with sound." She goes on, "When I focus on something, it's a little bit like a laser beam. [I used to compose] when everyone was sleeping; I could write until 2, 2:30 in the morning. Something happens with sound at that time—it's a little bit *lontano* [Italian for 'distant'], a little bit ghostly. You might hear something, but you don't really know what it is."

León also tells me that she thinks that one of the reasons she initially did well as a teacher is that she's "a very good sight reader" and "an ace" at solfège, which is another system of hearing, singing, and recognizing notes. "It's something that people get very im-

pressed about," she explains. In addition to Sillman's talent as a painter, she writes beautifully and passionately about art and artists, verbal skills that are fundamental to teaching.

Darrel Morrison went back to school in 1967 at the University of Wisconsin, stayed there to teach, and then went on to the University of Georgia in 1983, where he was the dean of the School of Environmental Design, until he retired in 2005. During the years of teaching, he was also accepting commissions for projects and writing about landscape architecture. When he was a dean, he insisted on teaching as well, so he could be connected to students and the fieldwork so central to his own practice. Samuel Delany taught at various institutions beginning in 1975, and closing with his time as professor of comparative literature and creative writing from 2001 to 2015 at Temple University, from which position he retired. When I interview him, his attitude about academia is easygoing. "Although I think I have a few interesting ways to look at writing and life," he says, "I'm not out to rock anyone's boat, unless it really rubs me the wrong way." At the same time, when he talks about teaching in *The Polymath*, he says, "You need to teach people that they're important enough to say what they have to say." He begins to cry, the only moment in the documentary when he shows any raw emotion. "If you don't do that," he goes on, taking off his glasses to wipe his eyes, "then you're not doing the right thing as a teacher."

Both León and Morrison tell me that the years since retirement from teaching have been extraordinary for their work. León says that her professional life "has increased tenfold" since retirement. When Morrison retired, he moved to New York and says that that's when his career really expanded. But if they hadn't been able to work creatively during their heaviest teaching years, none of these people would have been likely to see their artistic careers continue to blossom in their later, freer years. While there may be people who have artistic breakthroughs after a lifetime of not

doing anything artistic, they are quite rare. That depth and range of practice over the long run—trying, failing, and trying again—is invaluable.

Much has been written, most of it critical, about the impact of the explosion of MFA programs on the work being produced by students, but relatively little has been explored about the effect of the university as a main employer and patron of artists as faculty. As patrons go, the university is no better nor any worse than any other patrons throughout history: the church, the rich, Hollywood, the European welfare state. But every patron has its specific character and exacts its price.

=

Like Sillman, I worked in the fertile valley that was the New York media world in the 1980s and 1990s. I was an editor at the *Voice Literary Supplement*, but I also wrote for many publications that would send a willing and curious journalist nearly anywhere, and paid good money for the resulting articles. I whittled my job down to the minimum number of hours required to get health insurance; I think my salary was something like $35,000 a year in 1990. I had time to write, and if I wanted or needed to make more money, I freelanced. My models were writers like Joan Didion and Tom Wolfe, New Journalists and novelists whose purview was the splendor and strangeness of the world in the present. What was it to be alive now, right now? What was the character of the modern moment? Even the word *classic* enervated me. It seemed like a synonym for *safely sealed*.

Queerness, of course, had much to do with this. I was living a reality so underwritten, so invisible to most people, and so passionately alive that was changing, and changing the world, rapidly; I was in search of a language and form to say what I felt had never been said. Many official literary spaces, past and present, seemed to me

like suffocatingly heteronormative mausoleums where female char-
acters, and female writers, suffered and died early at an alarming
rate to everyone's satisfaction and crocodile tears. Queer women
and our queer lives were unimaginable, or repulsive, to nearly every-
one who had any power. The literary agent of a friend said to her
point-blank in the nineties that lesbianism was "box-office poison." I
imagine that what she meant by this was queer women writing about
queer women; for acclaimed men, it was an acceptable novelty.

That looked to me like a wide-open field for the previously un-
seen, unwritten, and unvalued. What was happening right this very
minute on the street, in the bars, in our lives was urgently neces-
sary to get down on paper. Also, being able to live by my wits in re-
sponse to the times was electric. That in-between position of the
journalist—in a scene and of it, but also not, scribbling notes in the
dark—had a particular, thrilling charge. Getting paid for diving
into whatever and then diving again into writing about it seemed to
me like the best possible way to live, and for many years, I did.

I continued working for magazines and newspapers through
the publication of both my first and second novels, but by the time
my second novel was published in 2004, it was clear to me that this
way of making a living was no longer sustainable. By the end of the
1990s, previously generous publications like *Details* and *Mirabella*
had folded; the internet was driving down the per word rate to
nearly nothing, or actually nothing. Many people I had known in
the media world were losing their jobs, or hopping from one van-
ishing publication to another, also tenuous one. In 2004, at forty-
three, I took my first teaching jobs. The academy has been my main
employer ever since, and it is the employer of nearly every other
writer and artist I know.

In making the transition from journalism to academia, I had to
shift my skills. The world of media wanted a writer to be smart,
fast, opinionated, and hyperalert to the new. Media asks, What's
happening? What's next? What does it mean? The academy wants

a writer to be smart, reliable, productive, and fair-minded. It asks questions like, How does your course fit into the aims of the department? And, if you want tenure, How is your work important, why, and to whom? These demands have some overlap and correspondences, but they are not the same. Plus, you have to be able to create syllabi, speak and understand academic language, and keep regular hours. The infamous "gonzo" journalist Hunter S. Thompson— drug-addled, unpredictable, and word-drunk—rode high in the heyday of *Rolling Stone*, but he wouldn't have lasted two minutes in a faculty meeting.

For quite a long time (or maybe always), I felt like a pretender as a teacher, not because I didn't feel that I could be helpful to students about writing fiction, but because I wasn't, and never wanted to be, an academic per se. I wanted to write my books, be good to my students, and keep body and soul together. I much enjoy the company of other writers, and other people generally. In the ways that the academy needs me to be, I am reliable. By the time I was forty-three, in addition to the fact that the lush media ecosystem was disappearing, I knew that I didn't want to function as cultural cilia anymore, and that being hyperalert to the new wasn't good for the slow, wayward course of my own imaginative work.

At the same time, the fair-mindedness that's required to teach even adequately has its own rigor and demand. As a teacher, it is my job to meet each student's work with an open mind. As a writer, however, I need to be obsessed with what obsesses me, no more, no less. The scent of one's own obsession can grow faint over the hours and hours devoted to the concerns of other writers, leaning into their fledgling voices to help them grow. More to the point, the habit of fairness saps obsession's irrational energy. In order to generate my own work, the last thing I need is to be fair. Or, as I once heard the fiction writer Grace Paley say at a reading, in response to a question about getting an agent, "You don't want to be thinking about that. You want to be thinking about what you're thinking

about." True enough—but in order to think, daily bread is necessary. Paley herself taught at Sarah Lawrence College for nearly twenty-five years.

═══

As my eighth-grade economics teacher told our class, there is no free lunch. Art-making moves according to its own timetable, but three meals a day and a roof over one's head are fairly nonnegotiable, ongoing basic needs. Those requirements require money, and for most of us, that money needs to be earned. Independent wealth always comes from somewhere, and many of those somewheres were built on the backs of others; tailor your conscience accordingly. All the other options have catches as well. Income generated from the art itself—book sales and advances, artwork sold, composing commissions, and so on—can be generous, but it is never guaranteed. That kind of money depends on market forces, which are mercurial. I have known artists who were supported by a spouse or partner, and that's a path, provided you want to make your partner your patron. Grants and fellowships are almost never lifelong sinecures.

Universities offer two things to full-time faculty: the free time built into the academic calendar; and, if you get tenure, job security for life. These benefits are what many a brutally overworked, precariously employed adjunct longs to attain. Indeed, in the United States, according to Alissa Quart's *Squeezed: Why Our Families Can't Afford America*, "middle-class life is now 30 percent more expensive than it was twenty years ago; in fact, in some cases the cost of daily life over the last twenty years has doubled. And the price of a four-year degree at a public college—one traditional ticket to the bourgeoisie—is nearly twice as much as it was in 1996. The cost of health care has almost doubled in that twenty-year period as well." Job security, health insurance, often free or reduced college tuition for one's children, and sometimes faculty housing at

below-market rates mean that being a tenured faculty member is like being a Swedish citizen compared to the anxiety-ridden economic situations of most people in the United States today. Plus summers off. And winter break. And regular sabbaticals. If you are an artist or writer who is also tenured at a university, you haven't only hit the jackpot compared to other artists. You've hit the jackpot of livability compared to most of your fellow Americans. Your average hedge fund manager may make a lot more money, but is unlikely to have anything like the average academic's open time or job security. The privilege is enormous, and growing by the day as the wealth gap in America continues to widen.

However, in order to make use of the academy's powerful gifts, you, paradoxically, have to be able to maintain your artistic practice and identity apart from the academy. If you become subsumed by the inevitable department politics, administrative tasks, and student dramas, or if you confuse a university's prestige with your own accomplishments, your own practice is likely to grow pale. I don't quite know that I have a specific word for the quality that León, Sillman, Morrison, and Delany share that enabled them to work at universities without losing themselves as artists. By "work," I mean that they were actually fully contributing faculty members. There are a very few artists and writers who are hired when they're already famous and get paid large sums of money by universities to do almost nothing, but I'm not that interested in the 1 percent whose job titles are ceremonial. It wasn't that these four artists didn't need the jobs, so they didn't care. They did need the jobs. It wasn't that they were so renowned that there was no danger of disappearing from the artistic stage. Both León and Sillman, for instance, received their most prestigious accolades after the age of sixty.

It may be a more subtle quality that enabled a healthy distance between them and the institutions on which they depended to keep the lights on. León says, "I always had my own point of view, and I didn't try to influence the students in my point of view. I thought,

That's enough, there's one of me [already]." Delany relates a funny
story in which he told a room full of graduate fiction students at
Temple that they should each choose an idea for a story, and then
tell him when they thought they could finish it and turn it in for
workshopping. The students freaked out, saying, No, *he* was sup-
posed to set a schedule. One student threatened to report him for
"not doing his job." Delany replied, "You're confusing writing a
story with writing a research paper or painting the living room."
He continued, saying that if they couldn't learn how to give them-
selves a reasonable writing assignment, "you will never write any-
thing at all." Sillman told a group of students, "Look, all I did in my
twenties was have horrible love affairs, just a series of miserable
failures. Then in my thirties, same thing. In my forties, I tried to
have a career as an artist. In my fifties, I got that together, but I blew
it on love. And in my sixties, it's been great as an artist, but hor-
ribly lonely. And that's all there is." The students, Sillman reports,
"looked horrified."

Even as they may have found meaning and even joy in teach-
ing, these artists have a quality that might be called *resistance*. León
resisted the narcissism of attempting to create students in one's
own image. Delany resisted doing the one thing artists must do for
themselves, which is self-authorize. Sillman resisted telling stu-
dents what they most want to hear, which is that everything will
work out in the end, particularly if your artistic career is successful.
Or, as Sillman puts it, "I learned how to say 'Fuck you' a really long
time ago." When Sillman says this, she is referring not to the uni-
versity system, but to something central to her work: the choice be-
tween figuration and abstraction that some of her earliest teachers
said she had to make. In fact, her refusal to make that choice has be-
come the hallmark of her art, calling to mind what Delany quoted
from Cocteau: "What your friends criticize in you, cultivate. It is
you." For all her self-doubt, she says, even as an insecure college
undergrad, "I knew how to say no" to an aesthetic binary that didn't

suit her, no matter how much it might have been received wisdom at the time. With her usual wryness, she comments, "Maybe it's 'cause I'm very deeply brave or maybe it's just because I'm dumb."

When dealing with power—the power of employers, the power of gatekeepers, the power of the critical establishment—being able to say no is perhaps the most crucial point of leverage. It's a common assumption that being able to say no to authority comes only with an equivalent, or greater, amount of power, money, and fame. However, it is, of course, precisely when one *doesn't* have as much power as authority that the ability to say no matters most, particularly if one is in it for the long run. Brown turned down that HBO job where her character just got coffee for the main male character, but, the last time I speak to her, she says that the phone hasn't rung in a while. "I'm still waiting for that call. Phone's right here just in case anybody wants me." She doesn't look too worried about it, but the inducements to cave in to the going orthodoxies and obligations—some sweet, some bitter—are continual. Resistance is as much a lifelong practice as making the art itself, and in this moment it may find its footing in small, continual acts rather than blazing last stands.

Sillman remembers that when she was in her early thirties and "kind of flip-flopping around," her mother told her that she could always go to law school, a suggestion to which Sillman thought, "Ugh." Instead, she realized, "What's the worst-case scenario? I'm not a famous artist. So what? Does that mean that they can tell me I'm not an artist? No, they cannot tell me that." Nevertheless, Sillman also recounts that in 2015, when she was living in Berlin without a studio in "a swanky apartment" that she couldn't "mess up," she figured out that she could make drawings on the bathroom floor, being careful not to get anything on the walls, but continue to the next part of the process—undrawing them in various ways—by washing them off in the bathtub. Later, she thought, "Damn, I'm really an artist. I made the art the whole semester in the bathroom."

She names this experience, when she was fifty-nine with many years of work, prizes, and shows already, as the moment when she finally knew that she was an artist.

Similarly, while Sillman calls herself "queer," throughout her life she has resisted the pressure to tag herself with a fixed point on the Kinsey scale. "It was mostly something that I was punished for," she recalls. "I kind of had different relationships, some with men and some with women, and therefore I wasn't a good, card-carrying queer and I got in a lot of trouble for it." However, she relates, "I just carried on being ambivalent." She is also a woman who didn't want to have kids and who isn't particularly domestic—in her Long Island house, she sleeps on a mattress on the floor and has little interest in decorating. She gestures to those all-white walls behind her. "Look—I have no art. None."

She connects her lifelong fluidity to abstraction, saying that part of its importance to her is "as a place of silence or privacy or non-entertainment. I respect the reserve that is inherent to abstraction. So, on a very fundamental, formal level I feel I've been trained as a human being to reject a certain kind of flag of allegiance." Really, she says, "I always say my sexual preference is painting."

Ambivalence, or what Sillman calls "awkwardness," doubt, and nonmastery, is also a form of resistance. Keats called it "negative capability," which he defined as the ability to dwell "in uncertainties, Mysteries, doubts, without any irritable reaching after fact & reason." Sillman is wary of what she calls "ideas" or, at times, "beauty." Instead, she moves toward and from the rough places where edges don't meet up and definitions falter. As she explains it, "I don't have any ideas. It's more about a kind of intensification of some moment, and then another moment and another moment, and a series of those intensifications in a row make something."

Ideas, of course, are the university's stock-in-trade. Sillman speaks, instead, of intensification, the in-between, the inchoate. Try explaining whether or not that will be on the final test. The ability to

disengage one's identity and art from an institution, whether that's an employer or a discourse, is a survival skill uniquely suited to this moment in the United States. What Sillman describes as abstraction's "place of silence or privacy or non-entertainment" is as endangered as the rainforest in a culture that relentlessly memes, monetizes, and funnels everything into the algorithm. Universities are mammoth brands; it is in the nature of brands to subsume and regulate their component parts.

In some times and places, resistance means living off your own land, shooting back, or moving to another country. In this time and place under these circumstances, for artists, it might mean something more like the belief in the inherent value of one's own work, no matter its instrumental use in producing money, group identity, clicks, tuition-paying students, or valorization according to the terms of the most influential critical opinions of the moment. What Sillman, Delany, León, Brown, and Morrison share is their refusal to be used in full even by systems in which they were fully invested. This requires not the momentary strength of the assassin, but the deep stamina of the double agent. They remain awkward, as it were, somewhat orthogonal to the system, perpetually between stations.

=

It also must be said that employment at universities can be a tricky business. Much has been written about the sometimes brutal impact of the culture wars on faculty, but there are other forces that can be just as destructive. I came into the university system in 2004, and by the fall of 2014 I was a full-time faculty member in the writing division at Columbia University's School of the Arts. Having gotten through all the periodic reviews and gates with flying colors, I was greatly surprised to be denied tenure. This is a much longer story, of course, but what's relevant to this book is what hap-

pened next. The School of the Arts, with its ruinously high tuition and spotty record when it came to granting tenure, had long been gossiped about among writers as a greedy and untrustworthy institution. Among the faculty, there were whispers about vast differences in salaries. When I was hired, more than one person said to me, "Don't work there. They'll use you up and spit you out just like they did to X, Y, and Z." When the tenure denial came down, it seemed that I had knowingly entered into a compact with a dodgy outfit, and now, at fifty-three, I was in big trouble.

For those readers who don't know this, when you are denied tenure, you aren't simply denied a promotion. You're fired. I knew that my chances of being hired anywhere, much less in New York City which had been my home over thirty years, were slim. The academic job market for writers is ferocious, and doubly so in this town; I had been on search committees where astonishing résumés came in by the bushels-full, most of which were set aside. A woman of my age without some major glory like a National Book Award on her CV was in danger of getting crushed; plus, what would I say about why I left Columbia? This wasn't just my fear. Around this time, the *New York Times* helpfully published an article on the front page that explained that women who lost their jobs after age fifty had less than a 50 percent chance of getting another job—any job. Because I lived in faculty housing, I would lose not only my job but also my home, not to mention my health insurance. I am my own breadwinner, and I was terrified. Inside the university system, as I've shown, one can live pretty or even quite well. If you're summarily tossed out of it, it gets cold fast.

I was also very angry. What had happened here? I had a few ideas about what had happened, and why, and to my eye it was an ugly business suffused with no small amount of cynicism, spite, and power-mongering. I also thought—and this is my fantasy, of course: those miserable people smelled the queer joy on me and they finally got me for it. You think all kinds of crazy things when

you're in freefall. However, because I and others felt that the tenure denial had been distinctly fishy and so baldly unjust, I also had to choose: to sue or not to sue? This is where a long, queer life came to my aid. I felt that if I sued, I would spend years, possibly many years, entangled with an institution and people that disgusted me, trapped in an interminable death match. If I won, I could get some sense of vindication, my tenure, and money. In other words, I could live out my days as a mean winner of a war I never wanted with people whose company had come to make me feel physically ill.

Or I could walk away for good and have faith that someone would come to meet me. My identity and my life did not depend on that place, no matter how formidable its Ivy League self or how bad my odds appeared to be. Or, as I put it to myself: *Goddamn, I can get another job. I'd rather go back to waiting tables.* That story, of course, was just a story like any other, a Wizard of Oz—my wholehearted belief in it is what kept me going down the road. Something else would happen. I would survive.

Indeed, someone and something did, and I ended up in a far better place than I ever could have imagined. I did get another job, infinitely better colleagues, and a home I love, but the damage from that time reverberated for many years. There was that long, dark period where I couldn't write. There was shame. There was the psychic work it took not to be consumed with bitterness and fear. Even more subtly, however, there was what feels like a permanent separation from and distrust of institutional literary power. I still enjoy the company of other writers, and, after a while, I did finish a novel—a notably dark one—and publish again. I believe in art as much as I ever did. But my own resistance to what can be the monoculture of MFA programs, and literary monocultures generally, has thickened. Although I work at a university, I am happy to be one of just two creative writing professors in a large and various English department. I have tenure, and I am extremely grateful for it every day, not least because of being denied it once. I teach undergrads,

for whom I am only a small part of their overall education, aspirations, and tuition. Our adjunct faculty are unionized. Maybe I've simply reverted to my earlier alt-weekly self, but I've discovered that I need the oxygen of a diversified field where lots of different people are writing about and fascinated by different areas of life and culture.

More troubling is another loss. Virginia Woolf wrote that in order to write, one must "kill the angel in the house," meaning the Victorian ideal of womanhood. The angel I have had to kill in order to write again and survive generally is my belief in meritocracy. Some might say that it was a little late in the day and that it had been my privilege to buy into it at all. Fair enough. But it was that belief that helped fuel my determination to write my books even when many gatekeepers thought they were "box-office poison." It was also that belief, however, that enabled me to numb myself to my own complicity with an institution that saddled its students with tremendous debt, causing aspiring artists to find themselves, as a former Columbia School of the Arts film student termed it in a 2021 *Wall Street Journal* article, "financially hobbled for life." In both aspects, the concept of meritocracy was an ideal that functioned as a defense against conditions I didn't want to reckon with, lest they slow me down. But I was brought to a halt, anyway. Meritocracy promises that your very special specialness will be duly rewarded, and sometimes those rewards arrive; the price, however, can be an ever-increasing disconnection from others and from oneself that is like severing your head from your body. You keep having the creeping feeling that something important has gone missing.

==

Sillman tells me that the subject of her work is time, but not "linear, progressive, chronological time. It's also about things that go backwards and forwards. Time is not an arrow. It's a structural

container." During our discussion of the three paintings that I found so moving, Sillman remarked of the stacked layers of color, "It's supposed to be like time that is stacked vertically and horizontally." For the 2022 Venice Biennale, Sillman hung a series of drawings all around the walls of the room—large ones on the bottom, many small ones on the top—that were described by *ArtReview* as "big paintings on dangling paper [that] moved like a film strip, her restless compositions semaphoring suggestions of human and animal bodies." The Biennale catalog described the room as "evoking a film strip or a home movie. . . . From the position of the viewer, her horizontal and tightly packed images form a fragmented spatial narrative."

Sillman says, "I was trying to make a clock." However, as with the *After "Metamorphoses"* video that I happened upon, her clock is composed of multiple series of images that can just as easily run backward, upside down, or sideways. Her clock is a way of moving, not a regulating machine, and that motion is perpetual. Our desires *is* conflicting; that conflict pushes forms and colors against other forms and colors, and then an arm reaches out or down or across. Maybe there is a face or the tracing of a body about to disappear—or appear? Maybe that happens over and over. Maybe you're never over it. Maybe you're just walking into a glorious found space, or walking out and walking away. Maybe the rectilinear plane on which you have staked your life is always filled with unnameable stuff that you nevertheless keep beginning with "dear friend" and ending with "love." Sending it out, again and again.

Descent

And then what? This is my main question for musician Steve Earle. After spending most of high school dropping acid and then dropping out. After hitchhiking around Texas while still in your teens to play gigs at coffeehouses and listen to music, with a stripper as a girlfriend. After marrying your first wife—not the stripper—at nineteen. After getting to Nashville that same year to get to the music and be closer to your hero, mentor, and dear friend Townes Van Zandt, a legendary country singer-songwriter with equally legendary appetites for substances. After the first divorce. After kicking around and kicking around and kicking around, trying to get a record deal in Nashville, as part of a progressive country scene that included Van Zandt, Rodney Crowell, Nanci Griffith, Lucinda Williams, and Guy and Susanna Clark, whose house was a hub for music-making and connection. After marrying your second wife at twenty-one. After leaving in the middle of the night for San Miguel de Allende, Mexico, because someone told you it's a soft life there. After a lot of drinking, a lot of dope, a lot of guns, a lot of cocaine, a lot of everything all the time. After the second divorce. After the third marriage, at twenty-six. After, by now, the two kids. After, finally, the record deal and the record, *Guitar Town*, made all, or many of, your dreams come true. After the heroin. After the money rolled in and the drugs you hadn't been

able to afford before became available. After a lot of time on the road. After the third divorce. After getting arrested in a brawl. After being strung out. After an ex-lover took a hit out on you (unsuccessful). After making another record high the whole time and the record, *Copperhead Road*, becoming a hit. After shooting holes in the floor of the tour bus for fun. After the assault charges filed by the third ex-wife. After the fourth marriage. After the failed intervention. After the various lawsuits. After the birth of the daughter who may or may not be yours. After the next two records. After the $500–$1,000 a day drug habit. After the crack. After selling the plane ticket that was supposed to take you to meet that big record company and using it to buy crack. After pawning the guitars and the motorcycles to buy crack. After the fourth divorce. After more lawsuits. After overdosing. After becoming homeless. After not writing any songs for four years. After your sister began praying for you to die, just so that all the pain would stop. After hallucinating that there was a SWAT team in your driveway and people lurking in the trees. After getting sent to Blackwood Jail in Tennessee, which included twenty-nine days of treatment at a rehab center at the beginning, and then, utterly raw, back to Blackwood to finish your sentence. After they wouldn't let you have a guitar, because it was too entwined with your addiction. After being so thin you looked like a ghost, and then, after getting clean, ballooning up to 265 pounds. After Townes, your hero, died at fifty-two, steeped in substances to the end. Now you're forty. Now what?

Earle, sixty-eight when we talk, tells me what came next: "journaling," suggested by his sponsor when he was first getting sober. From the journaling came short stories, published as *Doghouse Roses* in 2001. From the short stories, a novel, *I'll Never Get Out of This World Alive*, published in 2011. A contract for a memoir. Writing one haiku a day for a year straight. Writing for theater, and music for theater. An album a year. Acting in the television shows *The Wire* and *Treme*.

After is a long time. Redemption stories generally end with re-demption and an implied *Well, then, you know, life*, but that's a bit of a big area, life. Earle has been working for the last few years on adapting the 1983 film *Tender Mercies*, written by Horton Foote, into a musical. In that film, Robert Duvall plays Mac Sledge, a washed-up country-and-western singer-songwriter who finds him-self living at a motel in a very small Texas town. He falls in love with and marries the widowed motel owner, played by Tess Harper, who has a young son. When the movie begins, he's given up on music and pretty much everything else. After meeting Harper's character, though, slowly, in his own winding way, he gets sober and begins writing music again. The movie ends with him throwing a foot-ball to the boy, in a scene that makes the viewer feel the weight and beauty of the grace of the ordinary. How miraculous, we under-stand, that he's alive and present for this moment. How narrowly he escaped closing out his days face down on some strange ground, unmourned by people who had long since given up on him.

It's not hard to see why Earle would be attracted to this material. In the film, Betty Buckley plays Mac's ex-wife, who has nothing left for him but a restraining order. She's a glitzy Nashville-esque coun-try singer, all polish and big hair to Mac's rough-hewn, often semi-articulate, heartfelt integrity. He can't be anything other than who he is for anyone, a quality that has landed him outside the pale pos-sibly as much as his hard drinking. Earle tells me, "I'm an old hip-pie," and these days, that's what he looks like: salt-and-pepper beard, generous of belly, silver rings on his fingers, woven bracelets on his wrist, earrings in one ear. Sometimes he looks a little to me like Allen Ginsberg in his later years. He lives in New York City these days, and if I saw him on the street, I might think he was an old biker, or an East Villager toughing it out with his pit bull mix in the last rent-stabilized apartment in a building the landlord is dying to take co-op.

The Texas in his voice, though, would make him stand out in the latest fusion/plant-based/overpriced plywood outdoor dining shed

in the city while his practices of yoga, prayer, meditation, and sobriety might make him equally singular at a Texas barbecue. Also his fervent support of Bernie Sanders. Since he got sober, he's been married and divorced twice more. His eldest son, Justin Townes, died of a fentanyl overdose at thirty-eight, in 2020. His youngest son, John Henry, born in 2010, is severely autistic. One of the reasons Earle moved to New York was because he wanted to work in theater. Another reason is John Henry, because of the resources the city offers him. During the school year, Earle takes John Henry to school every day.

Like Mac, Earle seems incapable of manicuring himself into a smooth, easily consumed, single image. He has the deeply self-curated quality of an outsider artist, which, in many ways, he still is. Earle was born at the Fort Monroe Army Hospital in Virginia in 1955, where his father was stationed during his service in the army. The first of four children, he grew up mostly in Texas, where his father became an air traffic controller. His mother was hospitalized more than once for depression, and, this being the sixties, was treated three times with electroshock. Money could be tight and there were pressures on the family, but Earle's parents, as they appear in *Hardcore Troubadour: The Life and Near Death of Steve Earle*, by Lauren St. John, were caring people who never stopped trying with each other and their children. Addiction runs through his family of origin—a grandmother, a cousin, an aunt, and others. Earle began using various drugs at eleven. He ran away from home the first time in 1969, at fourteen. Although he started dropping acid in high school, he also spent hours and hours in the library, reading everything he could get his hands on. He kept running away until, at sixteen, his parents gave up on keeping him in school. Earle moved to San Antonio, where he worked in bars and played in coffeehouses and bars. He worked at a car wash for a while, at a carnival for a few months; he hitchhiked around a lot to listen to musicians he admired. He did a lot of drugs.

One night in Austin he was at a birthday party for progressive country legend Jerry Jeff Walker. At three in the morning, Townes Van Zandt arrived. In St. John's biography, Earle recalls, "He had on this gorgeous white buckskin jacket with beadwork on it that Jerry Jeff had given him for his birthday two weeks earlier. It was Jerry Jeff's own jacket. He gave it to him literally off his back. And Townes started a crap game on the floor in the kitchen and lost every dime he had and that jacket within forty-five minutes of arriving and then left an hour after that. I thought: 'My hero!'" In 1974, he moved to Nashville, where he quickly became part of a new wave of young singer-songwriters like Nanci Griffith, Lucinda Williams, Rodney Crowell, and, of course, Van Zandt. A scene grew. As St. John puts it, the musicians in this cohort "were inspired as often by Robert Johnson or Gram Parsons as they were by Hank Williams. Experimentation was their watchword." Earle recalls, "We were making art on purpose . . . We were a salon. I remember asking Richard Dobson, a really good songwriter who was fifteen or sixteen years older than me, 'Do you think [they'll be writing] books about this?' and he'd say, 'Absolutely.' It was the first time it occurred to me that I was in the middle of something. It was all about making art."

When I ask him about the country performers known as "the Outlaws" who were also transforming country music around this time—folks such as Merle Haggard, Waylon Jennings, Willie Nelson, Kris Kristofferson, and Hank Williams Jr.—he says that people, especially younger people, "have their ideas about what 'Outlaw Country' is. Their idea is that it was about those guys taking a lot of drugs. But that's not true. Hillbilly singers always took drugs. George Jones was the first person in Nashville that freebased. Amphetamines were the drug of choice in Nashville when I got there in '74. It wasn't about drugs. It was about creative freedom." He goes on to discuss how Waylon Jennings and Willie Nelson had both had it with the strictures of the country recording

industry by the early seventies and began going their own way. "Because they didn't behave like all of the other country artists and just do what they were told, they were called outlaws."

Or exiles, maybe. When Nelson left Nashville for Austin in 1971 and grew his hair long, he wasn't only going back home; he was moving from the epicenter of country convention to the epicenter of country reinvention. The Outlaws didn't want to make everything so pretty—loaded up with orchestration, studded with rhinestones, and mud-free, as conventional Nashville came to prefer in the seventies. From the beginning of his career, Earle also mixed his country with many other musical forms, particularly rock. Even *Guitar Town*, his first, and very successful, record, had listened as much to Springsteen as to the late 1950s bluegrass of the deeply Baptist Louvin Brothers. This was not always well received by the establishment. Nashville then, and often still, can have strong ideas about what country music is that seem to include ideas about whose country it is generally. In 2019, for example, when rapper Lil Nas X had a hit with "Old Town Road," a song that sure sounds like country, Billboard took it off its Hot Country list, saying it "does not embrace enough elements of today's country music to chart in its current version." Those "elements," many observed, were whiteness. With *Guitar Town*, because Earle had used the word *hillbilly* in the lyrics—a point of pride to him, and an insult to many in the South—some country stations refused to play it.

As Earle's career went on, he continued to defy Nashville norms. Or as he once put it, "I don't have anything to do with what they call country music. I haven't since my second record." In recent years, Earle may not have further endeared himself to the country establishment with quotes about Shania Twain being "the highest-paid lap dancer in Nashville" or Garth Brooks being "one of the worst singers I've ever heard in my life. . . . [He really] is kind of evil just because he sucks so much energy and music out of the business."

Like Sillman's relationship to abstract expressionism, Earle's

relationship to country music is dynamic, vexed, fruitful, close, confronting, and continually hopeful. The tradition doesn't just have to be *this*, they say. It could be so much more; in fact, it already is, if you just look. If "awkwardness, struggle, nonsense [and] contingency," as Tausif Noor said, were aspects of abstract expressionism that were already there for Sillman to see and love, the musical syncretism and working-class roots of country music are plainly there for the hearing, and Earle champions them. Throughout his long career, he has insistently loved the fullness and weird depths of country music, not just its shiniest, smoothest, most profitable incarnations. For Earle, the connections among the Beats, American folk music, Townes Van Zandt's "The Ballad of Pancho and Lefty," *The Lord of the Rings*, Hemingway, Graham Greene, Chet Baker, and *Spring Awakening*—among many other things that have influenced his work—flow like a river. Nor does he embrace country's tendency toward right-wing politics, as a longtime campaigner against the death penalty who also calls himself "a borderline Marxist."

Earle is known to be a talker, and when I talk to him, part of the pleasure is having a great conversational wander. We, too, are on Zoom, and he often leans close to the screen as he emphasizes a point. A question from me about his life ignites a story that winds around to sinister artifacts of World War II; he tells me that his fifth wife "ran off with the kids' soccer coach"; he tosses off pithy sentences like, "There's no difference between Stephen King and Edgar Allan Poe but a hundred years and a heartbeat"; he tells me that in the middle of reading Cormac McCarthy's *The Road*, "I said, 'Fuck you,'" and he hasn't picked up work by McCarthy since. "Every book of his bummed me out more than the one before. I don't think his intentions are good, and I think intentions count." It's very easy to talk to Earle. He says, "I'm the least mysterious person in the world, 'cause I've got such a big mouth." Although they are different men in nearly every conceivable way,

Earle reminds me of Delany in his voluble exuberance, his tremendous interest in just about everything.

I also keep wondering: How is Earle still alive? In the St. John biography, the drug consumption and general chaos of Earle's early years are phenomenal. I've condensed it here, but on page after page she details any number of events that could have killed him, or nearly did. Earle himself tells me, "I lost from thirty-five to forty," meaning that he made no music during those years in his life, because he spent all his time chasing drugs and being chased by the consequences of getting or not getting them. Along the way, so much got trashed: marriages, professional relationships, friendships, hotel rooms, the needs of his children. Buckets of money went down various drains, such as his veins. Or, I understand that he got sober, which is how he's still alive in a literal sense, but why did sobriety stick? The rehab to which he was dispatched as part of his jail term was certainly no guarantee. He says, "The reason I got sober is that I was locked up and I don't recommend that. I recommend going to the Betty Ford Center."

Nevertheless, it worked. Why some get sober and some don't, and why some stay sober and some don't, is a mystery that many have tried, and failed, to solve. Earle says, "I don't know. There's a lot of serendipity involved. I have no way of explaining it, and I'm not sure anyone else does either." He goes on to talk about God, but he says, "I don't think God does parking spaces, you know?" What I think he means by that is that God doesn't magically cure addiction, that the work on the ground is one's own. We must pull our own sleds in this life. Then he continues to a story about the first time he met spiritual teacher Ram Dass, whom he calls RD, in 2015, and whom he went to see in Maui every year until Ram Dass's death in 2019.

Once he got sober, he attributes the incredible expansion in his artistic practices—from singer-songwriter to fiction writer, actor, creator of theater, and so on—to one simple element: time. When

he first started out, he says, "I did believe that I was put here to do this one thing, and I didn't even think about doing anything else besides writing songs." As his drug use took over his life, though, he remembers, "I didn't have time to do anything but maybe write a song here and there," until even that stopped as well. In early sobriety, he explains, "When you were using the way I had been, it just seems like you've got all the time and energy in the world. So I started trying to do other things."

He continues, "The first time I went to Australia, I didn't even see a fucking kangaroo. I was an addict, so I saw King's Cross and prostitutes and drug dealers. So the second time I went to Australia, I was sober and it was a completely different experience. Everything was a completely different experience. My guitar playing took a huge leap forward. I got better at finger picking. I'm a way better singer, and that was because I was listening to Chet Baker records and I realized that I didn't have to sing at top volume all the time. I found out that my voice would do different things."

Exactly why sobriety stuck with Earle probably isn't knowable. What is clear, however, is that he reached for art the first instant that he could after he bottomed out, kept hold of it with both hands, and hasn't let go since. In an appearance with the singer-songwriter Shawn Colvin at the 92nd Street Y in 2016 after the release of their record *Colvin & Earle*, he said, "As you get older, it gets harder to write. I know people who have gotten older and stopped writing. I live in terror of that. I don't know how I would justify my existence, the space I take up on the planet, if I didn't write songs. It does define me to myself." When he was finally allowed to have a guitar in rehab, he wrote the song "Goodbye" in forty-five minutes. To my ear, it's one of the most beautiful and saddest songs in the world. Spare, slow, simple, it keeps returning to the refrain: "Was I just off somewhere or just too high / But I can't remember if we said goodbye." Emmylou Harris covered it on her masterpiece *Wrecking Ball*; to see the two of them do it in concert as they have often done,

not as brilliant young upstarts but as experienced older artists who have lived full lives, is to leave your heart on the floor.

If the spine of Earle's life is art, the body, literal and figurative, around it has morphed several times over the course of his life. In footage of Earle up to around thirty-five, he's all wired rockabilly and firepower, a classic, lean country-rocker boy, tossing back his long, brown bangs, singing at that top volume, sometimes an Axl Rose-esque bandanna wrapping his forehead. After getting clean, in a documentary about a performance at Cold Creek Prison in 1996, he's a big, nervous-looking man in dark glasses with mutton-chop sideburns, like a cross between Meatloaf and Roy Orbison. He's that guy in *The Wire* as well, playing an addict in recovery named Walon who becomes the sponsor of Bubbles, a police informant and recovering heroin addict. These days, he sits and stands foursquare in his boots when he performs, often closing his eyes when he's singing. It isn't just that his appearance has changed; his vibe has shifted from burning arrow to melancholy buffalo to tender elder.

The first time I saw him onstage, he was providing music to *Coal Country*, a theater piece about a horrendous mining accident in West Virginia in 2010 that killed twenty-nine men and the struggle with the mining company that ensued. Earle wrote the musical with Jessica Blank and Erik Jensen. It was first done at the Public Theater, received rave reviews, was put on hold by the pandemic, and then reopened at the Cherry Lane Theater in New York City. When the house lights went down and the stage lights came up, Earle was sitting on the side of the stage with a guitar and a tambourine, kicking things off with a sotto voce *Here we go*. In recent years, with his band Steve Earle and the Dukes, he has released tribute albums to Townes Van Zandt, his son Justin, Guy Clark, and Jerry Jeff Walker, all musicians he loved who have died. Like Patti Smith, he has taken on the role of mourner, his own work functioning in part as an archive of beloved artists who are gone—yet another garden of creativity, of influence, that is also a graveyard.

What has stayed the same through all the changes is the bandanna he always wears on his right wrist when he performs. It began as a sweatband when he was using flat picks and would sweat so much that he'd drop the picks. He didn't want to wear an actual sweatband and look like "an Olivia Newton-John video," so he tied a bandanna around his wrist. He doesn't sweat as much onstage these days, and he fingerpicks most of the time, but the wrist bandanna has become, he says, "a superstition. I'll freak out sometimes if I can't find one." The bandanna ties him to himself—skin to skin—over the course of more than half a century of making music as his life waxed and waned and waxed again.

Fate can hang by such a thread, a bit of cloth infused with a story. The woman I fell in love with who loved the shadows, who had come from a hard place and hard people, was very taken with the philosophical concept of "moral luck." A thumbnail definition would be that our ability to do the right thing or not, as well as to survive this life or not, is not altogether a matter of our will or high-mindedness or hard work. It is also produced by elements far outside our volition. We are neither as bad as we fear nor as good as we like to think we are; that one person survives certain circumstances and another doesn't owes as much to contingency as to conscious choice. It seems self-evident until you think about it for a minute, and then it becomes a bit unnerving.

When I ask Earle how, if at all, his experience with his son John Henry has changed his music, he replies that he doesn't tour as much, because John Henry, who lives with him during the school year, has to go to school. Covid, obviously, forestalled much touring as well. When I spoke to him, he had spent two years so far working on his adaptation of *Tender Mercies*, and he expected to spend at least another two years on it. Would that be possible if he was touring? More to the point, would he even understand the heart of that story if he hadn't gotten sober? Earle also tells me that he has "a lot of survivor's guilt, and Justin, you know, makes it worse." A child is

lost in *Tender Mercies* as well. The surface reason is that she gets in the wrong car with the wrong driver, but her decision to do so implicates Mac to some degree, and he knows it. The difference between who gets sober and who doesn't may come down to moral luck, but part of that moral luck may itself come down to who can stand to hold all the contradictory pieces of their life at the same time.

===

When I talk to Earle, as with all of the astonishing artists I interviewed and thought about for this book, I think I've had it pretty easy, but I also think about what it is that any of us reaches for to hold us together over the long run. In the years when I felt like a loser and couldn't write this or any other book, what brought me back to my work was a choice I had never made before: I discarded my identity for a year by writing an anonymous weekly column called The Magpie for *Catapult.* It was an experiment I had been wanting to try, and at that point I had nothing to lose. Yuka Igarashi, the editor of this book, was the editor of that column. As the Magpie, I roamed around the culture and the city and wherever, collecting elements that caught my eye and writing about them. I just moved toward what drew me, and set it before the reader in brief, associative essays that went where they would. I thought of them as a form of bricolage. When I wrote about Sillman's piece *After "Metamorphoses,"* it was for this anonymous column. It was strange, ironic, though, that if the first thing that connected me to the page was the assertion of self—*I,I,I,* in Joan Didion's famous formulation—the thing that reconnected me to it was the renunciation of self, or at least a public self. The one thing you can be sure of getting if you publish is your name on your work, but by letting go of my name, a more fundamental energy—the sheer pleasure of doing this, of transforming experience into prose—rose

up. I had feared that it was missing forever, but from the moment I started writing those columns, I discovered that it was right there, unstemmed. All I had to do to find it was drop my name, which is probably one of the first stories we learn to tell about ourselves.

For quite a while, my editor and my partner, the gardener, were the only two people who knew that the Magpie was me. When I wrote that column, I put things in it that I imagined they would like or find interesting or moving. My partner went with me on several expeditions to curious places and events, and then I would show him the column I wrote about them and he would offer suggestions. Sometimes he took pictures that we used when the column posted online. More than once, I wrote a sentence just to make Yuka laugh. I was writing toward, and in many ways with, them. The way I finally wrote this book was similar. The writer Martha Southgate, a friend since the 1980s, and I decided to talk to each other once a month about projects that we both couldn't finish, and couldn't quit. For me, it was this book. We talked for years, and we are still talking.

———

The destination of desire paths only becomes visible once you've followed them. At first glance, it seems out of character that Earle would have turned to writing musicals. It's a highly structured form that often wants to send the audience home happy and humming. It's also a collaborative form, which doesn't always come easily to Earle; he tells me that he quit *Coal Country* once during its making, because someone "wanted me to do something I didn't want to do as a performer. I can be rash, and I yell. My day job is not a democracy." Theater may not be a democracy, either, but it's also rarely a solo enterprise. Even one-person shows have directors, lighting designers, costumers, and many others.

When Earle got to New York in the early 2000s, however, he

saw *Spring Awakening*, and that made him want to create musical theater. A folk-rock musical based on an 1891 play by Frank Wedekind, it concerns the disastrous effects of repression and conservative mores on a group of teenagers as they begin experiencing their various sexual awakenings. It's beautiful, sexy, and dark. He also saw a revival of Stephen Sondheim's *Sweeney Todd*, which is about a nineteenth-century barber who creates quite a successful business (for a while) by killing people and making them into meat pies. It is also beautiful, sexy in its own macabre way, and dark. Seeing these, Earle remembered his love for the musical *Carousel*—beautiful, sexy, and dark. *Coal Country* mostly takes place in the aftermath of the mining disaster, as the survivors unite to fight the mining company for its negligence. For all intents and purposes, they lose. In all of these, as in *Tender Mercies*, there is a battle between the forces of conformity and exploitation (*Sweeney Todd* is also a grim parable about the Industrial Revolution and the way it grinds people up) and the wayward forces of creation, life, and desire.

In many of these, however, the establishment wins. Earle writes and sings the songs of the losers, or the ones who just barely survived with their skins and not much else. *Hadestown*, another Earle musical theater favorite, is a contemporary reimagining of the myth of Orpheus and Eurydice. As Margaret Atwood argues in *Negotiating with the Dead: A Writer on Writing*, "*All* writing of the narrative kind, and perhaps all writing, is motivated, deep down, by a fear of and a fascination with mortality—by a desire to make the risky trip to the Underworld, and to bring something or someone back from the dead." One way of looking at the arc of Earle's work is that he first brought himself back from the dead, and since then has tried to bring back others, on the stage if not in life.

If my question for Earle was, And then what?, the answer on the evidence of his trajectory might be that he made a shift not only in medium but also in intent. A shift in the artist's gaze, from in-

ward to outward. Not one man in the center of the stage, but many people on the stage, and the singer, the Orpheus, coaxing them into view, even if only briefly, through their art. Earle certainly has not become anonymous, but what he signs his name to has morphed from the lyric, which often expresses the drama of one soul, to the epic, which expresses the drama of many.

More than anyone else whom I interviewed for this book, Earle lost everything, including his artistic practice, and skidded barely a hair's breadth away from losing his life. The major turn here, it seems to me, isn't so much that community literally saved Earle's life or his art, but that when he got sober, he saw the resonances between his story and the stories of many others. His art, now, reverberates with those resonances not only in content but also in form. *This is how it is for me. How is it for you?* When you lose yourself and everything you know, either by intention or misadventure, you may find that you can create the company you need to rebuild by asking others that question. Or, as Ram Dass once said, "The game is not about becoming somebody, it's about becoming nobody."

———

Talking to Earle also makes me wonder: do we need the devil to keep doing this? The opposition without, the darkness within? The writer William Gass, whose work was notoriously difficult but also much admired by other writers, once commented that he identified with one of his characters, who said, "I want to rise so high that when I shit I won't miss anybody," a pungent and exact expression of an endless supply of ressentiment as creative fuel. A performer I know used to like to get so drunk before a performance that they nearly couldn't perform at all; from that edge, they could get where they needed to be to do the show. Anxiety is my devil, and we know each other well. Would I ever have written even one book if I didn't feel the urgency to report from an interior world that has

often felt as if it was burning down? To be more exact, would I ever have written even one book if I weren't terrified that no one could see—should see?—the flames and the smoke?

The psychoanalyst D. W. Winnicott once wrote, "In the artist of all kinds I think one can detect an inherent dilemma, which belongs to the co-existence of two trends, the urgent need to communicate and the still more urgent need not to be found. This might account for the fact that we cannot conceive of an artist's coming to the end of the task that occupies his [*sic*] whole nature." Among many other things, Winnicott is getting at the tension one can see in many artists, the endless push-pull of vanquishing one's demons and cozying up to them, rushing toward the world and standing apart from it, longing for mainstream glory and rejecting mainstream conventions. Were this tension, these contradictions, to be fully resolved, Winnicott suggests, the artist might cease needing so desperately to make art—come to "the end of the task." That impossible "dilemma" is art's engine, a perpetual motion machine. To call oneself an "outlaw," for instance, means that one's mental map still puts the center where it's always been, and that one defines oneself in relation to that center. Earle talks about his years of heavy using in many interviews, repeatedly invoking the devil that nearly killed him. He is always showing us that devil on his shoulder, always showing us that the devil didn't win today. He calls the devil to join him onstage, as it were, frequently.

To be clear, I don't think artists and writers necessarily have any more demons than anyone else, and the world bears down hard on many people. What I see in artists and writers whose practices have stayed alive over the long run is that Keatsian capacity to dwell in uncertainty, in what are often irresolvable tensions. When Sillman joked of herself that maybe she was brave or maybe just really "dumb," one could substitute the word *stubborn* for *dumb*. But one could also substitute the word *undefended*. Our desires is

conflicting, always. That continual friction generates considerable heat for making art, if you can bear it.

===

The second time I see Earle onstage, he is headlining the John Henry's Friends Benefit Concert at Town Hall, an annual event he puts together for the Keswell School, the school to which he takes John Henry every day. He is on the far left. With him are the musicians David Byrne, Kurt Vile, and Terry Allen, arranged in a large semicircle. Earle opens by explaining that the evening will run something like what he and Emmylou Harris used to call "a guitar pool," where musicians jam together and apart—a salon of sorts. What follows is loose, decentered; even from my seat high up in the audience, it feels as if we've been invited to hang out with friends. Earle tells us that they haven't rehearsed much, which only adds to the intimate feeling. This is the same stage, of course, where I saw León conduct the opera about the ICE raid at the kosher slaughterhouse. Tonight, though, it is a living room, a front porch. Earle is not so much the master of ceremonies as the welcoming host.

It so happens that this event takes place just a few weeks after Valda Setterfield's death, in her sleep, at eighty-eight. I've been thinking about her a lot, grateful to have spent some time with her. At Town Hall, we are just a few blocks from where the last Automat closed in 1991. Maybe it was one of those where she and Merce and Rauschenberg used to go, although I know that she probably wouldn't have cared for such fetishizing of relics of the past. She wanted, she said, to be part of *now*, and so she is, because I am thinking of her and will always think of her. Watching Earle and the others, I discern just a hint of what it might have been like in Nashville when Earle first got there, played with other upstarts like himself, and for the first time realized that he was "in the middle of something." He is still in the middle of something, although for

him that now includes many beloved ghosts. One of the songs he does was written by his son Justin.

I go backstage after to say hi, where the usual backstage throngs are thronging around. Earle is polite, but he has the expression of someone who has been deeply somewhere else and hasn't quite returned yet. Pulled into other conversations, he disappears into the crowd.

Epilogue: The Red Thread

The visual artist/writer/poet/teacher/weaver/performance artist Cecilia Vicuña, seventy-three, lay propped up on a sofa. "I'm very sick," she said. "I will be very tired, very, very soon." In the background of the Zoom frame, I could see plants, a window, a desktop. I had many questions for Vicuña, who was exiled from Chile in 1973 and whose protean art ranges so brilliantly among forms, countries, and spaces. A lifelong, recurring motif in her work is what she calls *precarios*: as she puts it, "installations and *basuritas*, objects composed of debris, structures that disappear, along with quipus and other weaving metaphors." Quipus, ancient inventions from the Andes, are knots in fabric that keep many kinds of records. The practice was outlawed by the Spanish in the sixteenth century. Lucie Elven, writing about a Vicuña exhibition at the Tate in 2023, comments that the quipu has "proved a useful metaphor for Vicuña: what was once a way of making sense of the world became a way of marking time and mapping loss." Winding through her body of work over decades is a red thread, sometimes a group of threads, that drop from ceiling to floor, or across a field, or at an ocean's edge, or along an urban street, or in many other places, precarious and tensile—a desire path that has traversed continents as well as years.

The critic Lucy Lippard has written:

If the precarios are the common formal thread, the action of weaving itself is the aesthetic and spiritual thread that runs through all of Vicuña's cultural production. ("In the Andes, they say that to weave is to give light.") Often the thread in Vicuña's work is combined with or stands for water. "The water wants to be heard," she says. "Everything is falling apart because of lack of connections. Weaving is the connection that is missing, the connection between people and themselves, people and nature."

I asked Vicuña about the *precarios*, which she first made at eighteen. "The day that my art began," she says without hesitation, "I was at the beach [in Chile] and I was in my bikini. I was freezing in the sun, but as happy as can be, and suddenly I felt the wind. It turned around my waist instead of just passing through, as if it was a snake. It was such a startling sensation. I became aware of the wind dancing my body. And I tell you, and my hair stands on end now as it did back then: I turn around and see the ocean. I see the waves and the light, the sun, the sky, and I become instantly aware that everything around me was as aware as I was, and that this awareness is what made possible my awareness. And I was so awed by this realization that I grabbed a little stick and I planted it in the sand to speak back to the ocean and the light and the sun and the wind, to say, 'Yes, I see. Yes, I know.' I somehow knew right away that this was it. And from that moment to today, that hasn't changed one bit. It keeps going because it has no bottom. You see? It's all giving, all revealing, all enticing, all appealing—all the verbs that you can apply."

We were both crying now. A few minutes later, I asked her if she was getting tired, and she said she was. "But I think we have enough with what I've given you," she said.

"Yes," I said.

Because Vicuña looked so frail that day that I feared she was dying, I didn't ask for another interview. Moreover, what she said to me was so moving that I hardly felt that I needed to ask anything else. I had the vague idea that I would write about her elegiacally, respectfully, from a carefully researched distance. However, when I next saw her about a year later, she was standing in the rotunda of the Guggenheim Museum with a microphone in the closing days of her career retrospective *Spin Spin Triangulene*. It was the end of summer. A small, vibrant woman with long, gray, braided hair and a huge smile, she stood at the center of a semicircle of people dressed all in white, rolls of red fabric in front of them.

I was in the audience with my research assistant and student, Lyss Witvoet, who had fallen in love with Vicuña's work in the course of helping me with this book. We were there for a one-time-only "living quipu" participatory event. "Look," said Lyss, "her braid has red threads woven into it, too." Vicuña and the people in white all held hands, then began to hum/keen/sing. Other folks in white came through the crowd, handing out stones. We were told to clack our stones together, which we all did, making the whole Guggenheim ring with the sound. As Lyss pointed out later, with this one gesture, Vicuña had transformed the entire Guggenheim into a musical instrument, played collectively with rocks. As we clacked, people on the ramps that spiral up the museum leaned over the walls and unfurled long bolts of red fabric very slowly. When all the fabric had pooled on the floor, Vicuña, who by now had gone a few floors above, ran down the spiral in her sneakers, whooping. No part of her looked anywhere near death.

With all of us carrying several unfurled bolts of red fabric, we processed out of the museum onto East 88th Street. A woman next to me said, "Where are we going?"

I said, "Apparently to a boat. That's what it said on the site."

"Oh," said the woman, "I thought the boat was conceptual. And will it move?"

"I don't know."

Interrupting the flow of the city with our collectively upheld, broad, red threads, each about a block long and two feet wide, we walked to the East River, like three very long dragons with many feet. *How little it takes,* I thought, *to create a ritual space. How happy I am right now.* We were marching somewhere, I wasn't exactly sure where, just like those young people in my father's home movies, so long ago.

I turned around to see that Lyss, a few feet behind me on a different skein, was grinning. Lyss was a poet and jewelry maker who used they/them pronouns and whose potential seemed vast to me. They were born in, what, 2001? What did the world look like to them, and what could I say I'd discovered on my path that started decades before they existed, and about the paths of those who'd begun before me? Often, when I described this book to people, they'd ask, "So what's the secret?," particularly if they were other artists or writers. I always dodged the question, not least because I didn't feel that I had an answer.

But on this day, as we threaded through New York, I thought about what I might say to Lyss, or anyone, about what makes for a long run. In the lives of the people I interviewed, and in my own life, will is certainly a factor. We push. However, of equal if not greater importance is willingness. Forces arise, within and without, and it's that willingness to turn in their direction, to yield, that seems to foster resilience. If Tania León hadn't been willing to be the rehearsal pianist for that interesting stranger. If Steve Earle hadn't been willing to get sober. If Valda Setterfield hadn't been willing to step up on that chair when it was offered. I was Lyss's teacher, and in the classroom we teach conscious effort, but in the world, surrender is often what leads the artist where they find they must go.

Power is obviously a player at the table as well, and power, like

a junkyard dog, can bar the gate. However, as Amy Sillman realized early on, while power can determine access and market worth, it can't tell anyone that they're not an artist. If there is a secret, maybe the secret is that this is the one power that power doesn't actually possess, no matter how loudly it barks that it does. If I were to offer any warnings to Lyss, or anyone, I would tell them not to fall for power's costume, to always to keep a bit of breathing room between themselves and power. And while I see community in the lives in this book, I also see that communities, like gardens, also contain mortalities literal and figurative. Taking Earle's life to heart, I might suggest that over the long run we lay places for our ghosts and welcome them in.

What I wouldn't say to Lyss, or anyone, is, "Exploit everyone you can, early and often," although I'm aware that history is full of artists and writers who seemed to exist primarily by cannibalizing everyone around them. The wreckage is well known. Ethics aside, being a full-time, full-on cannibal is exhausting, and most people don't have the stomach for it. I have encountered a few cannibals on this path, and what's strange about them, or perhaps not, is that they always seem to be starving. More to the point, their success rate, over the long run, doesn't seem much better than anyone else's.

What I've seen more often on this path is people cannibalizing themselves out of desperation. In her autobiography, *Zami: A New Spelling of My Name*, Audre Lorde tells a story about a dangerous job she had when she was eighteen. She worked in a factory that processed quartz crystals for radio and radar machinery; the factory was filthy and loud, with bad air. Lorde's job was reading the electrical charges of the crystals using a radiation-leaking X-ray machine, like all the rest of the Black and Puerto Rican women who worked there. Lorde's dream was to go to Mexico, but the bonus pay scheme at the factory, of course, was rigged. She figured out that she could bump up her bonus substantially by slipping away

to the bathroom and chewing down batches of crystals at a time, which made the work go much faster. She got to Mexico.

I have never forgotten this episode since the first time I read the book in the early eighties. My wish for Lyss, for anyone, is that they not have to chew glass to get the lives they want, but what else was Lorde going to do? In the world as it is now, particularly in the United States, more people than ever are in Lorde's position. There are undoubtedly many talented artists and writers among them. There is abundant inventiveness everywhere that is going to waste. Vicuña's *precarios* are one attempt to repair these losses, to reweave what has been broken. One red thread, against so much that can seem so unmovable.

Of course, Lyss hadn't asked me about any of this. Like every older person ever, I was composing a long scroll of advice for a young person who, at the moment, was chatting away to the bearded person on the next skein. Lyss waved. I waved back. Also like every older person ever, I marveled at Lyss's exuberance, and I took strength from it. The walk was long, and kind of hot, but there was Lyss right behind me. We passed a church. We passed a garden. I would keep going.

We arrived at the dock. The boat, which was yellow, was not conceptual. The people in white gathered up the red skeins and carried them onto the boat. Lyss and I sat up on top. Vicuña, a few rows ahead of us in a floppy sunhat, chatted and laughed with the many people around her. We headed out into the river, and we kept going for a long time, passing Roosevelt Island, Governor's Island, and all the various buoys and boats and ferries and detritus that populate the waterways around Manhattan. We kept going. Sometimes we would stop and then go again. After a while, I said to Lyss, "Does it seem like we've been on this boat for a long time?"

They said, "Yeah. Where are we going?"

"I don't know." I hoped I wasn't getting us both lost at sea.

The day unrolled in the late-summer sun. I felt the clammy

stickiness of being out on the water, my hair clinging to my face. Finally, somewhere just shy of the Verrazano Bridge, the boat stopped. People in the prow of the boat began unfurling the long red skeins onto the water. Nearby, a bell clanged on a buoy. A woman behind me said, "Un ofrecimiento. The offering." A few people began to sing softly. The wide red threads slowly, slowly sank.

And then we all just sat on the still boat for quite a while as the red threads disappeared. The sky turned mauve, then began darkening. Lyss went below. On boats nearby, lights came on. The city was far behind us, the buildings muzzy in the dusk. Ahead, open water. Around me, a few people in this temporary community were having quiet conversations. Mostly, though, it was silent. The boat rocked slightly with the movement of the water. I wondered how long we would sit there. I clacked the stones together in my pocket.

Works Consulted

Freedom

Author interviews with Valda Setterfield

"Valda Setterfield Dies at 88; a Star in the Postmodern Dance Firmament," by Alastair Macaulay, *New York Times*, April 21, 2023

"Making Work," by Arlene Croce, *New Yorker*, November 21, 1982

Feelings Are Facts: A Life, by Yvonne Rainer, MIT Press, 2006

Dia: Beacon, Fred Sandback, "Untitled (from 133 Proposals for Heiner Friedrich Gallery)," 1969

"Women's Music," in *Out of the Vinyl Deeps: Ellen Willis on Rock Music*, edited by Nona Willis Aronowitz, University of Minnesota Press, 2011

Emphasis: David Gordon and Valda Setterfield, KRDO-TV, January 27, 1984, New York Public Library for the Performing Arts, digital collection

The Mysteries and What's So Funny?, by David Gordon, January 3, 1993, New York Public Library for the Performing Arts, digital collection

Uncivil Wars: Moving with Brecht and Eisler, by David Gordon, March 13, 2009, New York Public Library for the Performing Arts, digital collection

"Arts and Sciences and David Gordon," by Arlene Croce, *New Yorker*, May 15, 1978

Uncivil Wars: Talkback, March 13, 2009, New York Public Library for the Performing Arts, digital collection

The Story Behind the Story: Mannequins and the Matter, interview with Valda Setterfield and David Gordon, Barnard College, October 8, 2012, New York Public Library for the Performing Arts, digital collection

Garden

Author interview with Darrel Morrison

Beauty of the Wild: A Life Designing Landscapes Inspired by Nature, by Darrel Morrison, Library of American Landscape History, 2021

Flowers and Fruit, by Colette, translated by Matthew Ward, edited by Robert Phelps, Farrar, Straus and Giroux, 1986

The Vagabond, by Colette, translated by Enid McLeod, Farrar, Straus and Giroux, 1978

Cheri and *The Last of Cheri*, by Colette, translated by Roger Senhouse, Penguin Twentieth Century Classics, 1995

Break of Day, by Colette, translated by Enid McLeod, Farrar, Straus and Giroux, 2002

Earthly Paradise: Colette's Autobiography; Drawn from the Writings of Her Lifetime, by Robert Phelps, Secker & Warburg, 1966

The Sun Collective, by Charles Baxter, Pantheon, 2020

The Blue Lantern, by Colette, translated by Roger Senhouse, Farrar, Straus and Giroux, 1977

Native Flora Garden extension, Brooklyn Botanic Garden, Brooklyn, New York

darrelmorrison.org

Desire

Author interview with Samuel R. Delany

"Samuel R. Delany, The Art of Fiction, No. 210," interviewed by Rachel Kaadzi Ghansah, *Paris Review*, issue 197, Summer 2011

The Polymath, or The Life and Opinions of Samuel R. Delany, Gentleman, directed by Fred Barney Taylor, 2007

"Samuel Delany Writes, Has Sex, Tells All," by Jason Silverman, *Wired*, May 6, 2007

Dhalgren, by Samuel R. Delany, Vintage Books, 2001

"An Introduction to Imaginative Literature, Part III," by Jeff Riggenbach, Libertarianism.org, Dec 1, 1975

Of Solids and Surds: Notes for Noel Sturgeon, Marilyn Hacker, Josh Lukin, Mia Wolff, Bill Stribling, and Bob White, by Samuel R. Delany, Yale University Press, 2021

"The Life to Come and Other Stories," by Eudora Welty, *New York Times Book Review*, May 13, 1973

Times Square Red, Times Square Blue, by Samuel R. Delany, 20th anniversary edition, New York University Press, 2019

"*Archiveography*," by David Gordon, davidgordon.nyc

Bread and Wine: An Erotic Tale of New York, by Samuel R. Delany and Mia Wolff, Fantagraphics, 2013

In Search of Silence: The Journals of Samuel R. Delany, volume 1, *1957–1969*, by Samuel R. Delany, edited by Kenneth R. James, Wesleyan University Press, 2017

The Motion of Light in Water: Sex and Science Fiction Writing in the East Village, by Samuel R. Delany, University of Minnesota Press, 2004

The Element of Lavishness: Letters of William Maxwell and Sylvia Townsend Warner, 1938–1978, edited by Michael Steinman, Counterpoint, 2000

Georgia O'Keeffe: A Portrait, by Alfred Stieglitz, Metropolitan Museum of Art, 1978

Dark Reflections, by Samuel R. Delany, Dover Publications, 2016

"On Samuel R. Delany's *Dark Reflections*," by Matthew Cheney, *Los Angeles Review of Books*, October 9, 2016

Taxi zum Klo, directed by Frank Ripploh, 1980

samueldelany.com

I'll Be Your Mirror

Author interviews with Blair Brown

"A Selfie in Fuzhou: In one man's photographs of himself over 60 years, lie glimpses of Chinese history," by Sowmia Ashok, *Indian Express*, March 31, 2019

A Life in Portraits, by Tong Bingxue, Foreign Languages Press, 2012

"Portraits of Change," by Yang Guang, ChinaDaily.com, May 25, 2012

One-Trick Pony, directed by Robert M. Young, 1980

Altered States, directed by Ken Russell, 1980

Continental Divide, directed by Michael Apted, 1981

The Days and Nights of Molly Dodd, 1987–1991

Fringe, 2008–2013

Orange Is the New Black, 2015–2019

Copenhagen, by Michael Frayn, directed by Michael Blakemore, 2000, New York Public Library for the Performing Arts, digital collection

"AKA: Roni Horn," *W* magazine, October 31, 2008

"Menopausal Gentleman," by Peggy Shaw, 1996

"Blair Brown: A New Force on 'Orange Is the New Black,'" by John Jurgensen, *Wall Street Journal*, June 22, 2016

"David Hare Captures His Muse on Stage," by Benedict Nightingale, *New York Times*, October 22, 1989

The Story Behind the Story: Mannequins and the Matter, interview with Valda Setterfield and David Gordon, Barnard College, October 8, 2012, New York Public Library for the Performing Arts, digital collection

Alice's Adventures in Wonderland & Through the Looking-Glass, by Lewis Carroll, Bantam Classics, 1984

My Name Escapes Me: The Diary of a Retiring Actor, by Sir Alec Guinness, preface by John le Carré, Viking, 1996

"The Panorama Mesdag," by Mark Doty, in *Open House: Writers Redefine Home*, edited by Mark Doty, Graywolf Forum 5, Graywolf Press, 2003

"On Jeanne Moreau," by Patti Smith, *High Times*, January 1977

"*Fringe* Vet: Series Became a 'Boy Show' After Launching with Female Hero," by Matt Webb Mitovich, *TVLine*, January 17, 2016

"Blair Brown's Historic Connection to 'Orange Is the New Black,'" by Andrea Morabito, *New York Post*, June 17, 2016

Exile

Author interviews with Tania León

"Exiles," by Roberto Bolano, translated by Natasha Wimmer, in *Between Parentheses: Essays, Articles and Speeches (1998–2003)*, New Directions, 2011

Tania León's Stride: A Polyrhythmic Life, by Alejandro L. Madrid, University of Illinois Press, 2021

Everything She Touched: The Life of Ruth Asawa, by Marilyn Chase, Chronicle Books, 2020

Letters to a Young Novelist, by Mario Vargas Llosa, translated by Natasha Wimmer, Picador, 1997

The Sensual Nature of Sound: Four Composers, Laurie Anderson, Tania León, Meredith Monk, Pauline Oliveros, directed by Michael Blackwood, 1993

"Chapter 9—Paris: Studying with Boulanger," by Charles Fisk, https://charlesfisk.wordpress.com/memoir/part-1/chapter-9

"A Composer Puts Her Life in Music, Beyond Labels," by William Robin, *New York Times*, February 7, 2020

"An Interview with Tania León: A Tread Through Time," by Isabel Merat, *Opera Culture News & Magazine*, https://www.operaculture.com/post/an-interview-with-tania-le%C3%B3n-a-tread-through-time

"Martha Mooke: Walls, Windows, and Doors," by Frank J. Oteri, newmusicusa.org, April 1, 2014

Hometown to the World, music by Laura Kaminsky, libretto by Kimberly Reed, conducted by Tania León, The Town Hall, November 5, 2022

Tania León: Teclas de mi piano, Albany Records, 2022

Tania León: Indigena, Composers Recordings, 2007

Tania León: In Motion, Albany Records, 2011

"Judy Collins: *Wildflowers*—with the Harlem Chamber Players," conducted by Tania León, The Town Hall, February 25, 2023

tanialeon.com

The In-Between

Author interviews with Amy Sillman

"In Which the Magpie Sees Wild Boars as Lost Children," by Stacey D'Erasmo writing as the Magpie, *Catapult* magazine, March 16, 2017

"Shit Happens: Notes on Awkwardness," in *The ALL-OVER*, by Amy Sillman, Portikus, Frankfurt; Dancing Foxes Press, Brooklyn, New York; Mousse Publishing, Milan, 2017

"Amy Sillman's Breakthrough Moment Is Here," by Jason Farago, *New York Times*, October 8, 2020

"Amy Sillman," by Hilton Als, Goings On About Town, *New Yorker*, October 23, 2020

"Amy Sillman's Philosophy of Doubt," by Tausif Noor, *Frieze*, issue 217, March 2, 2021

Amy Sillman, by Valerie Smith, Contemporary Painters Series, edited by Barry Schwabsky, Lund Humphries, 2019

"Hodgkin's Body," by James Meyer, in *Howard Hodgkin*, Tate Publishing, 2006

Letters on Cézanne, by Rainer Maria Rilke, translated by Joel Agee, North Point Press, 2002

"Dana Carvey Remembers George Bush, From Muse to Friend," by Dana Carvey, *New York Times*, December 7, 2018

"Universities as Arts and Cultural Anchors: Moving Beyond Bricks and Mortar to Artist Workforce Development," by Amanda J. Ashley, PhD, and Leslie A. Durham, PhD, paper funded by *Research: Art Works*, National Endowment for the Arts, 2019

Faux Pas: Selected Writings and Drawings of Amy Sillman, by Amy Sillman, After 8 Books, 2022

Squeezed: Why Our Families Can't Afford America, by Alissa Quart, Ecco, 2018

"Over 50, Female and Jobless Even as Others Return to Work," by Patricia Cohen, *New York Times*, January 1, 2016

"'Financially Hobbled for Life': The Elite Master's Degrees That Don't Pay Off," by Melissa Korn and Andrea Fuller, *Wall Street Journal*, July 8, 2021

"Power 100: Amy Sillman, no. 44," artreview.com, 2022

La Biennale di Venezia, *The Milk of Dreams*, Amy Sillman, 2022

amysillman.com

Descent

Author interview with Steve Earle

Doghouse Roses, by Steve Earle, Mariner Books, 2002

I'll Never Get Out of This World Alive, by Steve Earle, Mariner Books, 2012

Tender Mercies, directed by Bruce Beresford, 1983

Hardcore Troubadour: The Life and Near-Death of Steve Earle, by Lauren St. John, Harper, 2003

"Steve Earle says that he makes an embarrassing amount of money for a borderline Marxist," by Steve Newton, earofnewt.com, June 6, 2012

Steve Earle To Hell and Back, Live at the Cold Creek Correctional Facility, Henning, Tennessee, June 25, 1996. https://vimeo.com/14538666

The Wire, HBO, 2002–2008

Coal Country, written by Jessica Blank and Erik Jensen, original music by Steve Earle, directed by Jessica Blank, Cherry Lane Theater, April 2022

Negotiating with the Dead: A Writer on Writing, by Margaret Atwood, Anchor Books, 2002

In the Heart of the Heart of the Country, by Willam H. Gass, New York Review Books Classics, 2014

"Communicating and Not Communicating Leading to a Study of Opposites," by D. W. Winnicott, in *The Collected Works of D. W. Winnicott*, volume 6, *1960–1963*, edited by Lesley Caldwell and Helen Taylor Robinson, Oxford University Press, 2016

John Henry's Friends Benefit Concert, Town Hall, May 15, 2023

Steve Earle: Live in Nashville 1995, Shout! Factory, 2014

Steve Earle and the Dukes: Guy, New West Records, 2019

Steve Earle and the Dukes: JT, New West Records, 2021

Steve Earle: Guitar Town, MCA Nashville, 2006

Steve Earle: Copperhead Road, MCA Nashville, 2006

steveearle.com

Epilogue: The Red Thread

Author interview with Cecilia Vicuña

"Cecilia Vicuña," by Lucie Elven, *London Review of Books*, vol. 45, no. 8, April 13, 2023

"Spinning the Common Thread," by Lucy R. Lippard, in *The Precarious: The Art and Poetry of Cecilia Vicuña*, edited by Catherine de Zegher, Wesleyan University Press, 1997

"Ex-termination Living Quipu: A Performance by Cecilia Vicuña," Solomon R. Guggenheim Museum, August 30, 2022

Zami: A New Spelling of My Name—A Biomythography, by Audre Lorde, Crossing Press, 1982

ceciliavicuna.com

Acknowledgments

This book could not have been written without the vital companionship of Andrew Altschul, Mary Bly, the Brown Foundation Fellowship Program at the Dora Maar House, Mary Byers, Maud Casey, Chris Castellani, Ava Chin, Bill Clegg, Alice Elliott Dark, Fordham University, Sarah Gambito, Jeanne Heifetz, Yuka Igarashi, Thomas Kopache, Fiona McCrae, Daiken Nelson, the New York Public Library for the Performing Arts, Cynthia O'Neal, Elizabeth Povinelli, Erica Ridley, Martha Southgate, Lyss Witvoet, Marc Wolf; and, of course, all of the artists and writers who were so generous with their time and wisdom.

Love

STACEY D'ERASMO is the author of the novels *Tea, A Seahorse Year, The Sky Below, Wonderland,* and *The Complicities* and the non-fiction book *The Art of Intimacy: The Space Between.* She is a former Stegner Fellow in fiction, the recipient of a 2009 Guggenheim Fellowship in fiction, and the winner of an Outstanding Mid-Career Novelist Prize from the Lambda Literary Foundation. She is a professor of writing and publishing practices at Fordham University.

The text of *The Long Run* is set in Haarlemmer MT Std.
Book design by Rachel Holscher.
Composition by Bookmobile Design & Digital
Publisher Services, Minneapolis, Minnesota.
Manufactured by Versa on acid-free,
30 percent postconsumer wastepaper.